IMAGES OF ENGLAND

BUSHEY

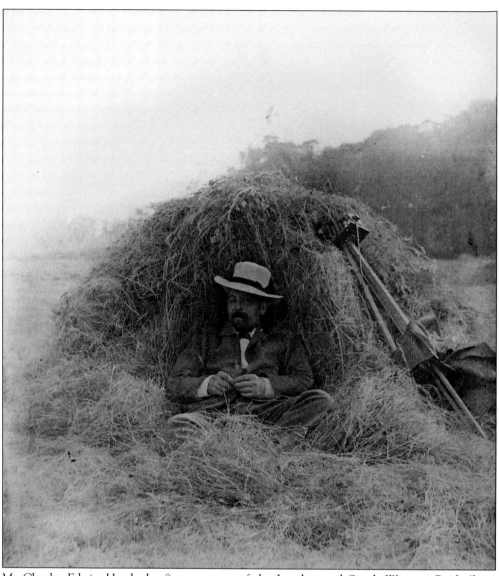

Mr Charles Edwin Head, the first manager of the London and South Western Bank (later Barclays) in Bushey, relaxing on one of his photographic excursions, in about 1910.

This book is dedicated to all the amateur and professional photographers of Bushey who made it possible.

IMAGES OF ENGLAND

BUSHEY

BRYEN WOOD

BUSHEY MUSEUM

First published in 1997 by Tempus Publishing
Reprinted 1998

Reprinted in 2011 by
The History Press
The Mill, Brimscombe Port,
Stroud, Gloucestershire, GL5 2QG
www.thehistorypress.couk

ISBN 978 0 7524 1042 5

Typesetting and origination by
Tempus Publishing Limited
Printed and bound in Great Britain.

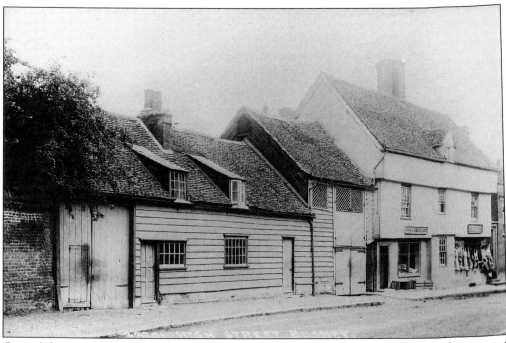

One of the ancient weather-boarded cottages on the left was, for a short time at the turn of the century, the Conservative Workmen's Club; it was, however, not a great success, as it did not have a licence. Later it briefly became the Parish Reading Rooms. The jettied building on the right survives today. Here, in 1905, it was occupied by White's greengrocers and Fisher's butchers.

Contents

Acknowledgements

The photographs in this book are from my own collection and that of Bushey Museum. Acknowledgements and thanks are due to the very many people who have donated their photographs to the Museum collection or allowed them to be copied for it. There are too many of them to be thanked individually, but if donors recognise their photographs in this book, I hope they will be understanding and pleased. A few photographs originated from collections in Watford Museum and Watford Reference Library, to whom I am also grateful for their help.

In compiling the historical information for the captions I have used information given by donors of photographs and also the work of local historians Mary Forsyth, Tim Groves, Norman Hedges, John Hodgkins, Grant Longman, Cliff Williams and, particularly, the late Max Hoather. The responsibility for any errors is, however, entirely mine.

Lastly I would especially like to acknowledge the help I have had from Mark Hastings and Michael Pritchard in photographic work, from Sheila Gadsden in word-processing and from Grant Longman in checking and proof-reading.

Introduction

The early history of Bushey is not well established. There has so far been almost no serious archaeological exploration of the area, but chance finds confirm that there were people in Bushey from the Palaeolithic period through to the Iron Age. The main road through Bushey Heath and Bushey was a Roman road and many Roman finds, including part of a tessellated pavement near Chiltern Avenue, indicate some Roman occupation.

The earliest written references suggest that in about AD 700, Bushey was granted to the monastery of St Albans by King Offa, although there are questions about the authenticity of the record. The first indisputable account of Bushey is in the Domesday Book of 1086. 'Bissei' was described as comprising arable farmland and pasture with some meadows and an area of mature oak woods large enough for a thousand pigs to forage in. There were two mills, which would have been watermills on the Colne. The population was very small – less than a hundred people. The first Norman lord of the manor of Bushey was Geoffrey de Mandeville who came over with William the Conqueror. His son, also named Geoffrey, died in conflict with King Stephen and began a pattern in which many successive Bushey lords chose the wrong side in the turbulent Middle Ages and were killed or executed. Even as late as 1696, Sir William Parkyns, lord of the manor of Bushey, was executed for treason, having plotted to restore James II. Neither did the manor remain intact, as the manor of Bournehall was created from it by, or in, the thirteenth century and the minor manor of Hartsbourne emerged in the fifteenth century.

Bushey parish at the time of the Conquest may have been linked with Watford and it certainly then belonged to St. Albans Abbey. In about 1160, Bushey parish became indepen-dent of St Albans and was established as a rectory (that is, the parish priest had the rights to the tithes himself). Although not rich, the parish was large, as it stretched from the Middlesex County border down to the River Colne. It was not until this century, in 1906, that 'New Bushey', that is, Oxhey village and Chalk Hill, were transferred to Watford, when Bushey Urban District Council was established. Bushey Heath ecclesiastical parish was formed in 1889.

Although the rights to hold a weekly market on a Thursday and an annual three day fair from 25 July were first granted in about 1140, Bushey remained a quiet agricultural village until the nineteenth century. There was little industry except that which supported the farmers. In more recent times, some Bushey men walked to work in Stanmore or Watford breweries and some women and girls worked in the silk mill in Watford and in the smaller mills in Bushey. Some straw plaiting was undertaken but Bushey was on the fringe of the plaiting area centred in Luton. There was some brick and tile making and there was work on the railway from 1835

onwards. The Bushey population was still less than one thousand in 1801. It grew to over 6,000 by 1901 and it is just under 24,000 today.

Bushey's major natural asset has always been its relative height – the highest point in South Hertfordshire is on Bushey Heath. Despite occasional outbreaks of cholera and typhoid, Bushey's water was long recognised as better than that which was available to most people in the north London outskirts. In the eighteenth and nineteenth century, some London families boarded their children with Bushey families to avoid the city epidemics. Some other London families bought or built country cottages or small estates, particularly at Bushey Heath after the enclosure in 1809.

It may have been Bushey's reputation for health which led Dr Thomas Monro to purchase an estate at Merry Hill in 1805. Dr Monro was physician to the Bethlem Royal Hospital (Bedlam), a consulting physician to George III and a noted patron of the arts. He had helped Turner, Thomas Girtin and John Linnell before they made their reputations and he was a competent amateur artist himself. When he moved to Bushey, he helped some of a new generation of watercolourists, such as Henry Edridge and William Henry Hunt, who came to stay with him at Bushey on many occasions. Together with Thomas Monro's sons Alexander, Henry and John, they produced a wide range of drawings and watercolours of Bushey and district which are a unique record of a small English village in the early nineteenth century. Thomas Monro died in 1833 and his Merry Hill Cottage was later demolished to be replaced by Haydon Hill House.

In 1873 a rising young artist, Hubert Herkomer, who had been born in Bavaria, visited one of his early patrons, Clarence Fry, who lived on Chalk Hill. Herkomer liked nearby Bushey village and when he found a pair of cottages and a studio for rent in the High Street near Melbourne Road, he took them on. In the next ten years, Herkomer established an international reputation as a portrait painter. In 1883 the Herkomer Art School was built very near to his studio and for the next twenty-one years the School drew several hundred art students to Bushey. Herkomer himself, in due course, made new reputations as a social realist painter, a print maker, a theatrical innovator and a film pioneer. Between 1888 and 1894 he built Lululaund, an enormous Romanesque mansion in Melbourne Road, which was filled with colour and carving. It was built as a celebration of the artistic genius of the Herkomer family. The tragedy was that although Herkomer had four children, none of them had surviving issue. The direct line died out in the 1930s. Lululaund was offered as an arts centre to Bushey Council but they turned it down and it was demolished in 1939.

When Herkomer retired from his Art School in 1904, one of his best students, Lucy Kemp-Welch, took it over. She changed it to a School of Animal Painting as she excelled in that field, but by 1926 she herself retired from teaching. Her pupil Marguerite Frobisher continued the tradition of art tuition in Bushey until the 1960s. A few of the many art studios which were built in Victorian and Edwardian Bushey survive today, as reminders of the unique story of nearly two hundred years of artistic endeavour in this small community.

In the early twentieth century, the railway helped Bushey expand. Many new jobs were created by the growth of industry in and around Bushey Hall Road, along the Watford Bypass and in Watford itself. The first council houses were built in Bushey in the early 1920s and in later years much of the additional housing has been for service families working in defence establishments in Stanmore and Northwood.

After the Second World War, Green Belt legislation protected much of the open space around Bushey, albeit some of it became golf courses and school fields. The green ring around Bushey has helped to maintain a distinct community identity and resist absorption into Watford or Harrow.

The photographs in this book cover the hundred years from the 1860s to the 1960s, the time of the most radical changes in Bushey's long history.

Bryen Wood
Bushey Museum

One

Bushey Village

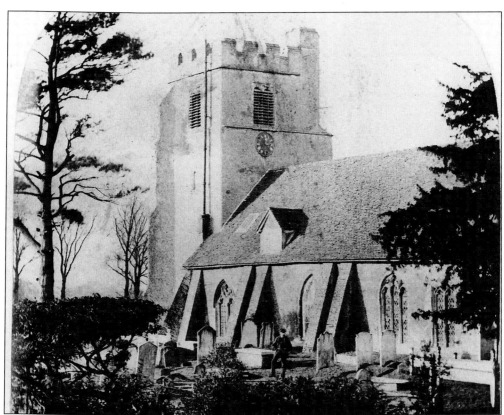

The south side of Bushey's Parish Church of St James the Apostle on 5 January 1866. The photograph has been pasted onto one of the back leaves of the ancient Parish Register and is the earliest known of St James. The heavy brick buttresses support what has become a very dilapidated structure. The dormer window illuminates the gallery reserved for Bushey Manor. In 1870, a new south aisle replaced the buttresses, the gallery and dormer were removed and all the walls were faced with knapped flint.

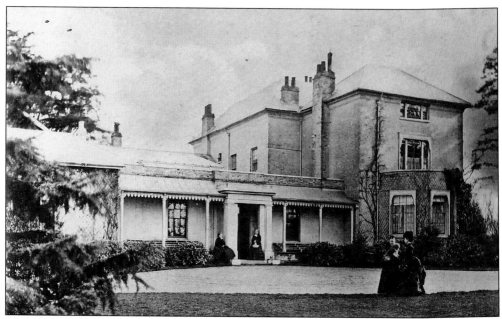

The rambling old manor house of Bushey Manor in 1870. It was mainly a seventeenth-century building standing in 52 acres of lawns, lakes, gardens and paddocks where Bushey Hall School now is. There was a fine collection of ornamental trees, some of which survive. Earlier Bushey manor houses were sited down near the Colne, near Bushey Hall Farm.

The lord of the manor in 1870 was General Sir Edward Walter Forestier-Walker who had commanded the Scots Guards in the Crimean War and was then Commander of H.M. Forces in Scotland. The manor was rented out to the Taylor family who had their business in Calcutta. After many other tenants the manor house was demolished in the early 1920s, to make way for the Junior Royal Masonic School for Boys, now Bushey Hall School.

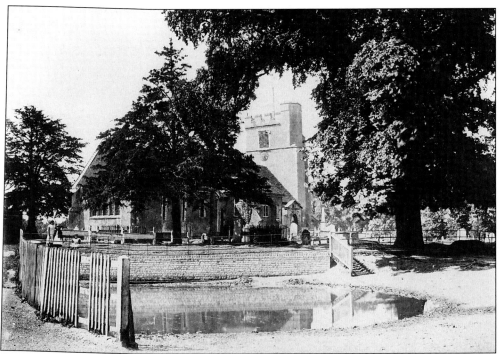

St James' Parish Church from the High Street just before restoration and enlargement by Sir George Gilbert Scott in 1870/1. The projecting Bournehall Manor private room and gallery together with the old north door were replaced by the new north aisle.

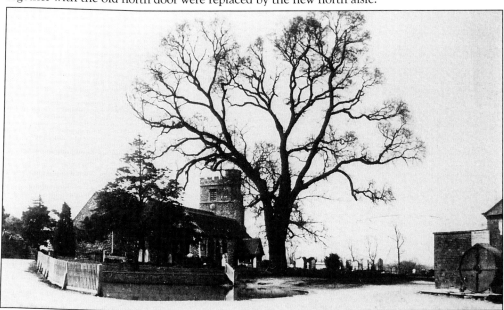

Until the Colne Valley Water Co. laid their mains in 1875, Bushey village's only public water supply was the wheel-pump next to the cottages where the green now is. The pump's proximity to the churchyard led one commentator to observe that Bushey folk were forced to drink their ancestors in solution. The pump disappeared with the cottages in 1913, but its site is marked by a stone slab on the green.

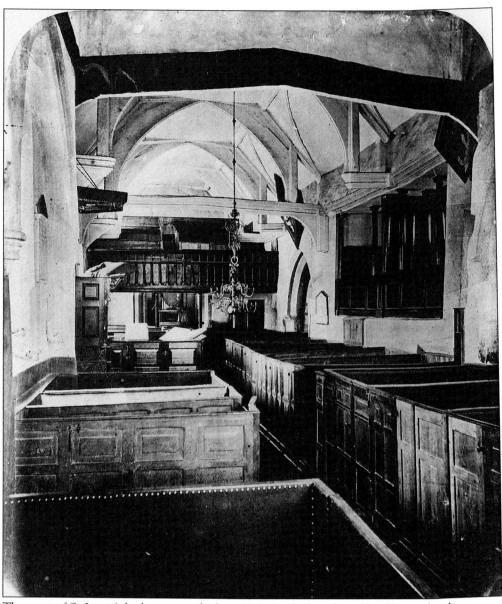

The nave of St James', looking towards the tower, just before the restoration and enlargement of 1870/1, when the ancient box pews and galleries were swept away. The organ was at the tower end and the Jacobean pulpit was in the centre of the nave, almost opposite the main north door. The only artificial light came from the brass chandelier hanging in the centre, which had been presented to the Church in 1727 by Richard Capper, the lord of the manor of Bushey. The pulpit and the chandelier survived the restoration.

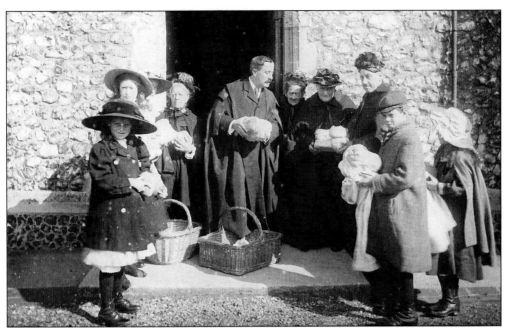

Distributing the Fuller Bread some time in the Edwardian period. Dame Elizabeth Fuller died in 1709 and her tomb in the parish churchyard records that 'twelve wheaten loaves [be given] to twelve poor people of the Parish upon this stone on every Sunday for ever'. Permission was later granted to make the distribution at the west door of the church. The charity is now incorporated in that of the Reveley Almshouses.

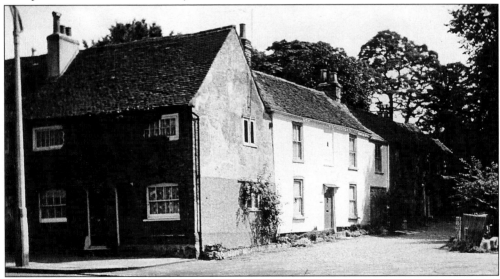

Rectory Lane with Prospect Cottage and the old Institute with its attendant verger's cottage, all in shadow, in about 1960. The Jacobean Institute and the cottage have been replaced by the brutalist Church House. The first schools in Bushey were held in the Institute and the Anglican National School for boys opened there in 1826. Conditions were so poor that when the non-conformist British School (now Ashfield School) opened in 1846, virtually all the pupils transferred and the National School closed shortly afterwards, much to the chagrin of the Rector.

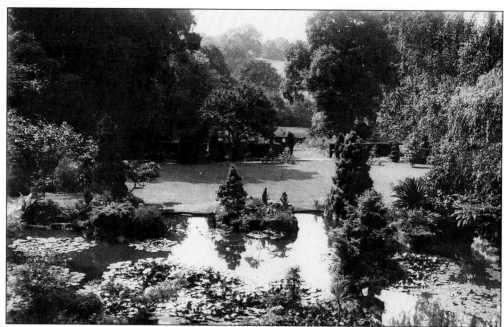

The Old Rectory gardens were laid out by Mrs Montague Hall, the then Rector's wife, in the Edwardian period. Before Kemp Place was built, the gardens stretched down to the stream alongside the churchyard.

Opening a St James' Summer Fair in the early 1960s. Franklin Engelmann, the broadcaster, who lived nearby in Old Redding is at the microphone attended on the left by Sir Harold Emmerson, churchwarden and on the right by Rector Chivers. The Fairs were always held in the garden of the Old Rectory, a Jacobean building with Victorian extensions.

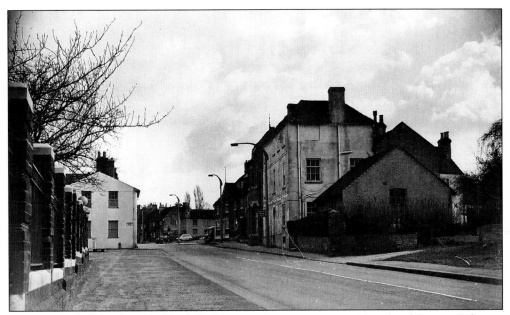

Grove House in about 1960, shortly before demolition, presents a dilapidated front to Falconer Road. An eighteenth-century house with Victorian additions, it had been a boys' boarding school in the early nineteenth century and then became established as the village doctors' group surgery. Dr William Webb Shackleton, a cousin of the explorer, was 'medical officer and public vaccinator' for Bushey and he also made his home there from the 1890s to the 1930s.

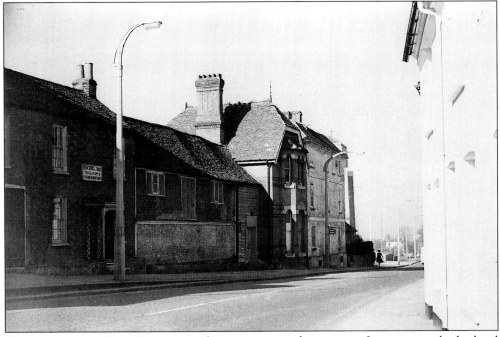

The barn next to Grove House served many purposes this century. It was variously the local Girl Guides Headquarters, a dancing school, a kindergarten and the home of the Bushey Community Association, amongst several other functions. It was greatly missed despite its shabby appearance.

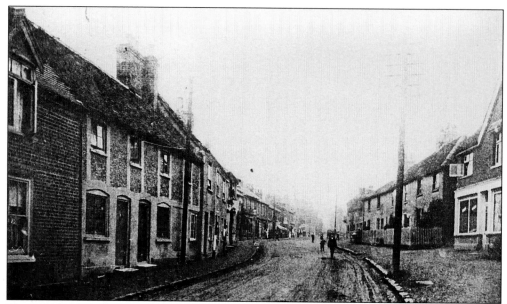

The only known photograph of all five cottages on the green taken in about 1905, shows how tiny they were. The narrow passage up to the church was known as the Twitchell (sometimes Twychell). The location of the present Conservative Club was then Miss Bayley's British and Irish Spinning and Weaving and Lace School, which showed its products in a shop window.

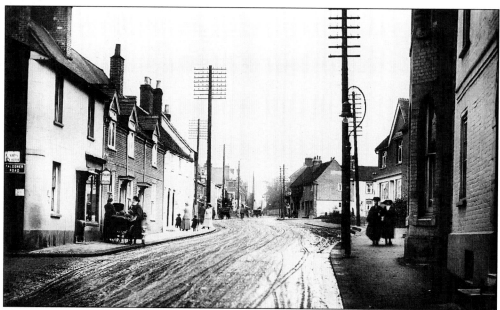

The cottages on the green were demolished in 1913 and the green given to Bushey UDC by Robert Attenborough of Haydon Hill on condition it remain permanent open space and never be used for any purpose. Middleton's little shop on the corner of Falconer Road sold china and toys besides being an agent for Pullars, who cleaned and starched collars.

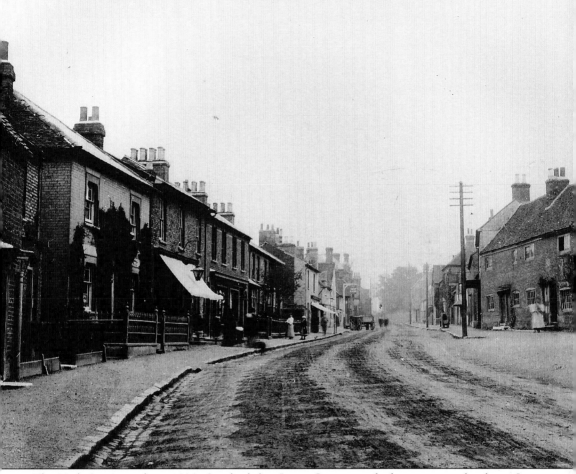

The High Street in about 1890. On the left is Lewis Cottage with the ornamental railings. In 1897 it became Bushey's first bank – a branch of the London & South Western. There are a few purpose-built shops, but little gardens still front the street. There are kerbs and some street drainage, but the road was muddy in winter and dusty in summer. It was not properly surfaced – with tarmacadam – until 1914.

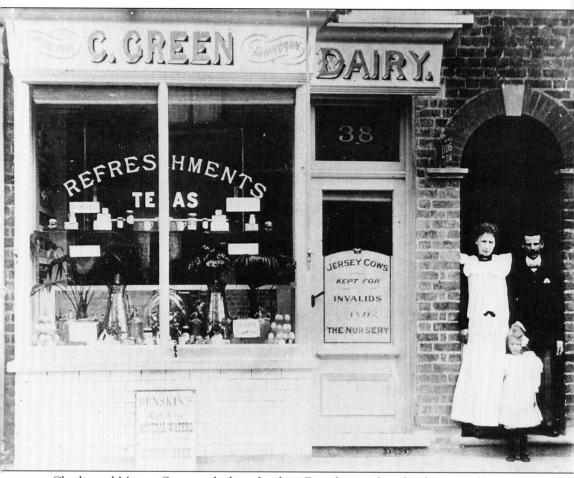

Charlie and Minnie Green with their daughter Dorothy stand in the doorway of no. 38 High Street, where they lived above their dairy in about 1900. They served refreshments in the tiny shop as well as selling and delivering dairy products from Green's Farm in Coldharbour Lane.

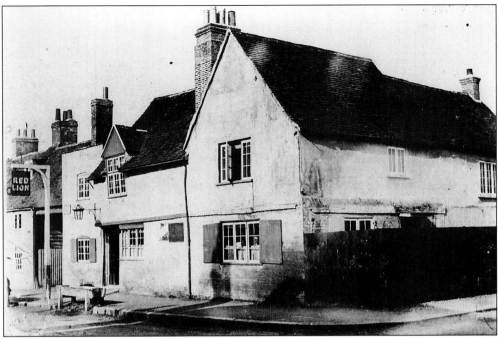

The old Red Lion in the High Street was a late medieval building. It was a principal inn and most of the nineteenth-century census returns show up to twelve lodgers or travellers staying there on census night. The church vestry and sometimes the manor court were held in the inn for many years. It was demolished in about 1895 just after Rudolph Road was cut through its side garden.

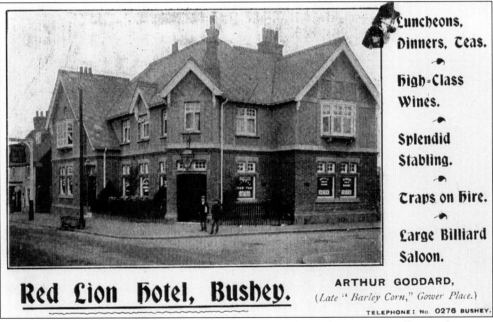

Luncheons, Dinners, Teas.

High-Class Wines.

Splendid Stabling.

Traps on Hire.

Large Billiard Saloon.

Red Lion Hotel, Bushey.

ARTHUR GODDARD,
(*Late " Barley Corn," Gower Place.*)

TELEPHONE: No. 0276 BUSHEY.

The new Red Lion was built as an hotel and continued to take in guests, albeit rather more comfortably, if Arthur Goddard's trade card is to be believed. He was mine host from 1905 to 1912.

House-building in Rudolph Road started in 1895 but the plots were quite slow to sell. The Bushey Urban District Council Offices were erected in 1909 and were extended as here on the right, to form a Fire Station in 1921. The new Council Chamber, later added to the left end, did not come until 1936.

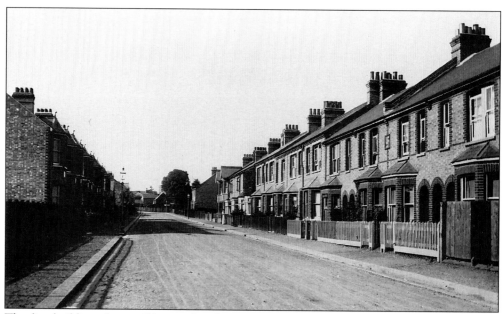

The first building plots in Glencoe Road were sold in 1899. By about 1910 much of the Road was developed but there are gaps on the right where there is access to Lucy Kemp-Welch's studios.

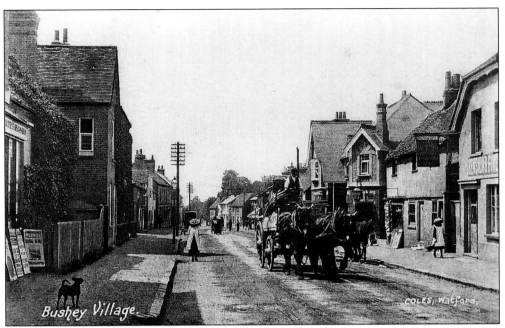

In 1905, a street piano is trundled up the middle of the unmade High Street as a waggonload of timber is drawn up the long hill by a weary team. Ivy House opposite the Red Lion lives up to its name.

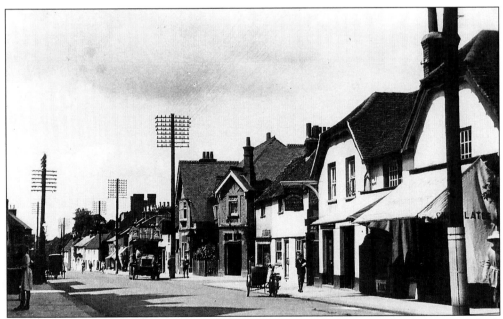

Almost 20 years later in 1924, the road has been made up and telegraph poles dominate on both sides of the Street. The Robin Hood beerhouse is shortly to close, but the village fishmonger, Allen Anker, next door, continues to thrive.

21

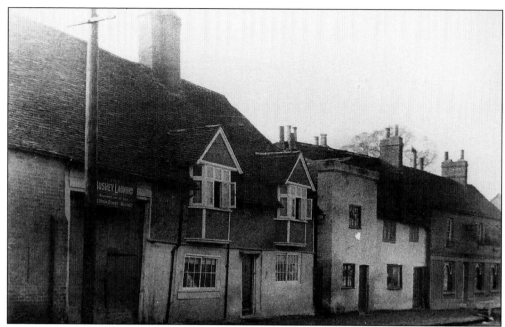

The Bushey Laundry operates in a much adapted medieval hall house demolished in about 1910. The Laundry then moved to Walton Road. The cartway with sign has now ultimately given way to Kemp Place. The White Hart alone survives from this row once known as Brick Place.

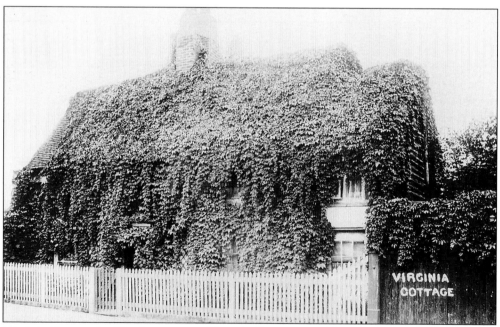

Virginia Cottage justifies its name as Virginia Creeper engulfs it. Ivy House is immediately on the right and the photograph was either taken in 1910, when the old shops on the left were demolished, or the photographer has blanked them out. Virginia Cottage in turn was demolished for what ultimately has become the Bushey Branch of the National Westminster Bank.

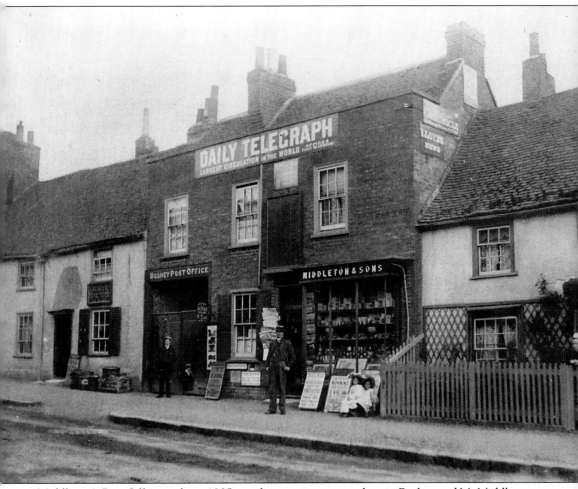

Middleton's Post Office in about 1905 was the most important shop in Bushey and Mr Middleton stands proudly outside. The Post Office remained as Middleton's on this site, albeit from 1910 in more modern premises, until the 1930s and then under successive owners until the 1970s.

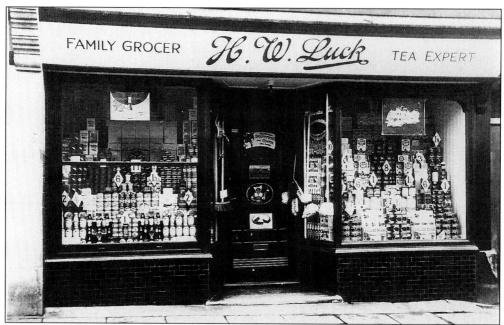

Mr H.W. Luck proclaimed his expertise in tea in his shop at 49 High Street for most of the 1920s. Despite the coincidence, the present day dentist, Mr Luck, next door, is no relation.

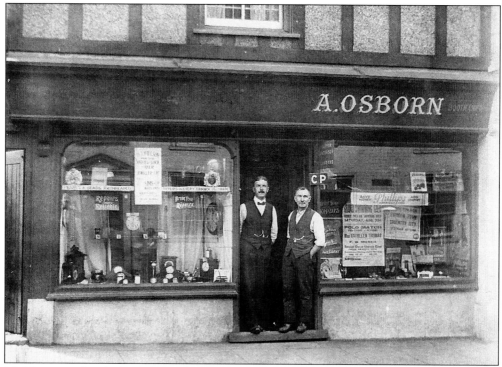

Mr Morrison, the clockmender and Mr Arthur Osborn, the bootmender, stand in the doorway of the shop they split between them at 51 High Street in 1925.

24

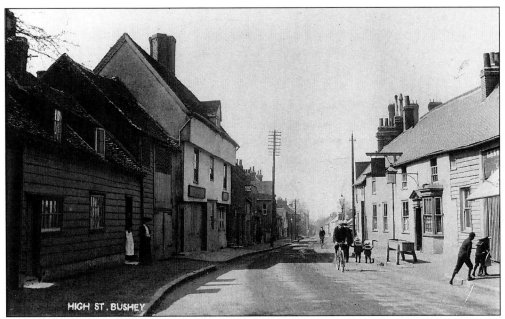

The Bell had been a principal Bushey inn since the seventeenth century. It shared the provision with the Red Lion of accommodating the manor court, public auctions and inquests. Until the post office network took over, it was the local posting station and the established coach stop. It was demolished in 1965. Clearly, sailor suits were well in fashion in about 1905.

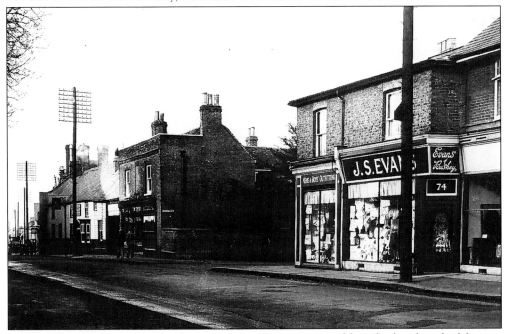

Next to The Bell was Unitts, the principal village grocers, although the shop had been a temperance coffee tavern in the nineteenth century. On the opposite corner of Park Road, James S. Evans was the last draper and outfitter after about one hundred and fifty years of this trade on the site. The art of window dressing had not made much impact in Bushey in the 1950s.

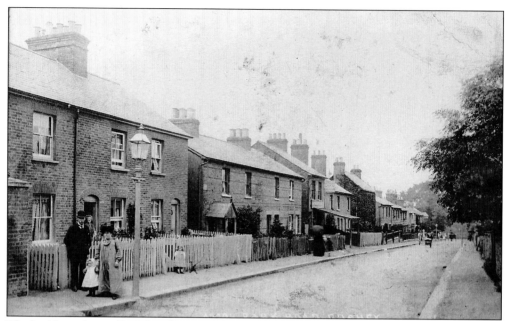

The building plots in Park Road were sold at auction at The Bell in 1862, but the development was piecemeal over the next forty years, giving the road its attractive variety. The Swan was built in 1866 and has remained little changed since then.

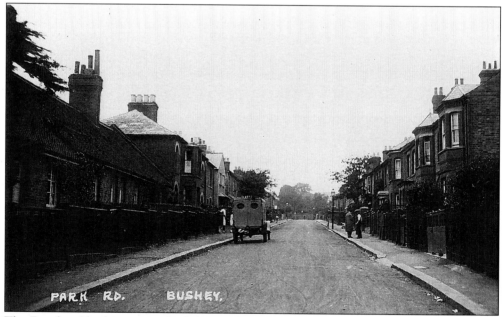

The Reveley Almshouses on the left, now known as Reveley Cottages, were built in 1883. George Johnson Reveley of Bushey Heath left a bequest for the cost of their construction, but the land was purchased from a public subscription fund set up by George Lake of Bushey House and John Middleton, the Bushey postmaster.

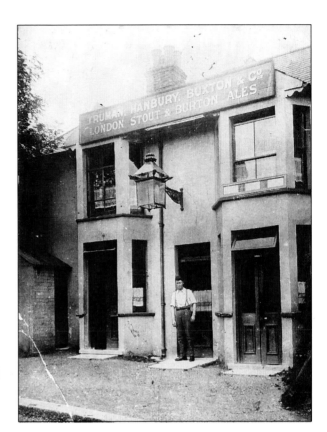

The old King Stag in Bournehall Road was built as a beerhouse in the late 1860s. In 1926, the new landlord, Fred Lack stands under its magnificent lantern, but the old pub is about to be redeveloped in the unlikely roadhouse style it has today.

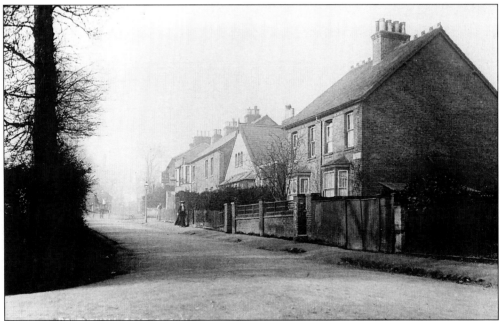

Despite its relatively modern appearance, Bournehall Road is one of the most ancient highways in Bushey. It provided access to the Moatfield and thus the site of the demesne of the manor of Bourn(e)hall for many centuries.

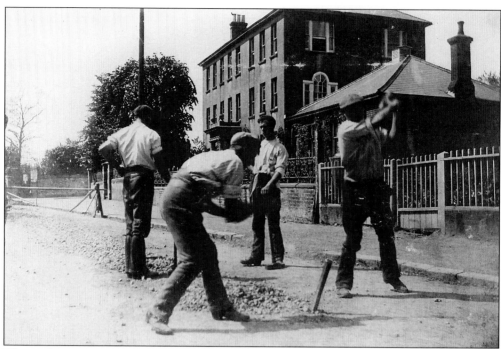

The road structure invented by John McAdam consisted of pieces of stone 'no bigger than will go into a man's mouth'. Coarse sand, rain and the iron-rimmed wheels of carts compacted the surface layer such that, before pneumatic drills, it could only be broken up with spikes and sledgehammers. A road gang in 1900 are working in the High street near Bournehall which was a large Georgian House, the home of Miss Elizabeth Milner, an engraver trained by Herkomer. In the nineteenth century it had been the Bournehall Academy, a boarding school for boys.

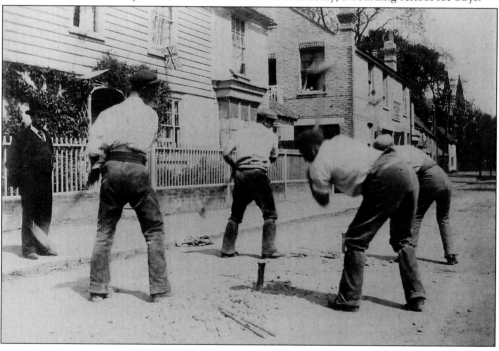

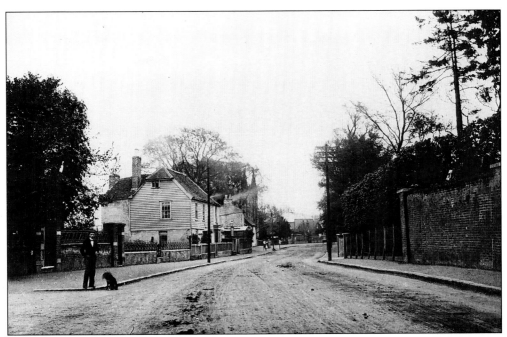

In 1890, a smart young friend of the photographer stands on the corner of Bournehall Road. Behind him the weather-boarded Urbino conceals Mrs Bruton's Model Stables, where horses could be hired for the day. The twin spires of an early Congregational Church, which had to be pulled down in 1904 due to subsidence, partly obscure the glass roofs of the Herkomer Art School.

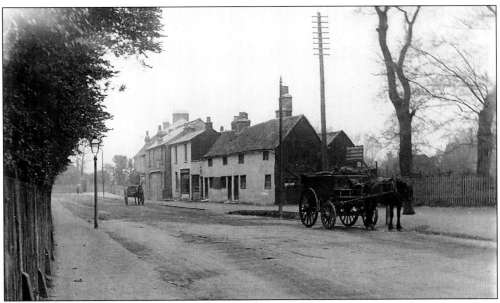

In about 1905 George Spinks sold bicycles and spares from Koh-i-Noor Cottage and Mrs Kilby had a tiny general store where Koh-i-Noor Avenue was cut through just before the Great War. A vacant plot awaits the Bushey Co-op, built in about 1930.

The tumble-down building on the left was variously known as the Old Smithy or the Old Forge, but its main business was as a farriery. A further twist is that the farrier or shoesmith in 1905 was named Goldsmith. Beyond are the glass roofs of Herkomer Art School on the Rose Garden site.

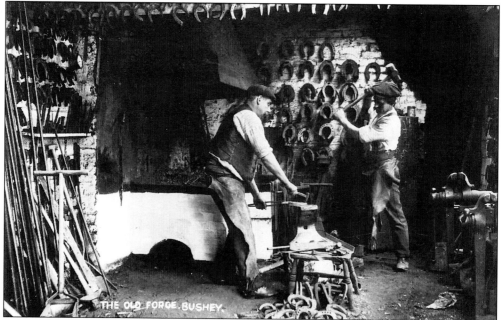

THE OLD FORGE. BUSHEY.

Inside the farriery, described here as the Old Forge, they appear to be mass producing horseshoes.

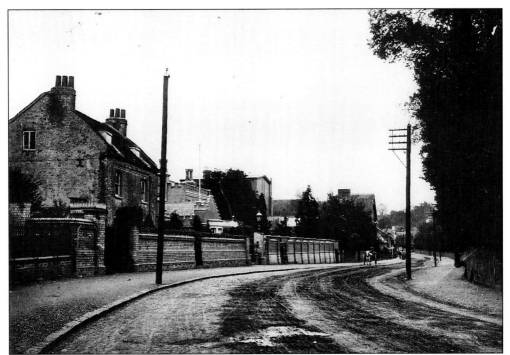

In about 1890 the derelict cottage on the left is about to be pulled down to open up the front of the Herkomer Art School behind it. The School entrance is marked by the gas lamp. Beyond The Cloisters, the Herkomer Theatre looks imposing but plain. Its roof was converted in 1912 to form a major daylight film studio for Herkomer's new filming ventures. Melbourne Road is hardly apparent.

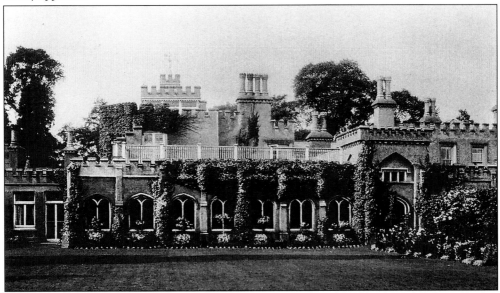

The Cloisters, formerly Rosebank, was a small 1840s villa which had been extended many times, ultimately with the imposing cloister along the back of the house and crenellations overall. It was declared unsafe and irreparable in 1988 when the site was redeveloped. It is not to be confused with the cloisters built into the Herkomer Art School next door.

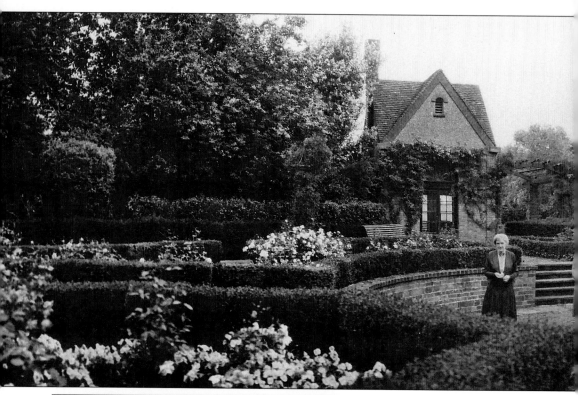

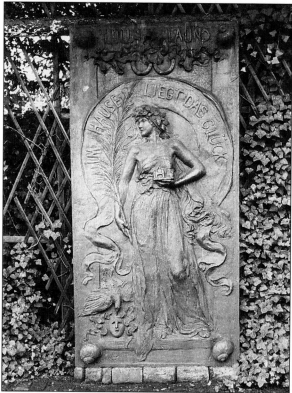

A feature in the Rose Garden at the end of the pergola was the seven foot bronze panel from Lululaund, a maquette of which is held by the girl. The panel weighed many hundredweights, but it was stolen on the night of 12 September 1967. The inscription, roughly translated, reads: 'Happiness lies in the Home.'

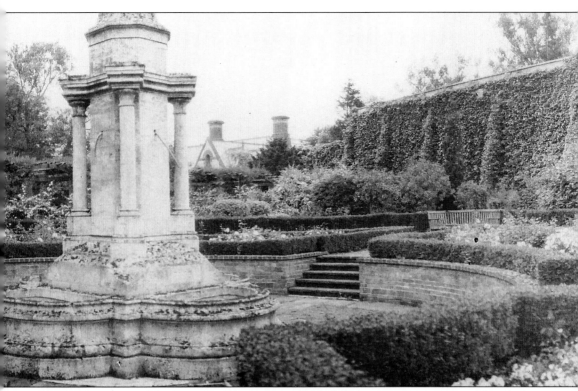

A panoramic view of the Rose Garden in about 1930 while it was still a private garden. Lady Margaret Herkomer is in the sunken area with Mrs Lulu Herkomer, the widow of her son Lawrence. Lululaund, named after Sir Hubert's second wife, who was also nicknamed Lulu and who was Lady Margaret's sister, is in the background. The Rose Garden was laid out in 1912 by the famous landscape designer, Thomas Mawson, in exchange for a portrait by Herkomer. It occupies the site of the Herkomer Art School of which the ivy-covered wall on the right is a remnant. It was bought by Bushey Urban District Council from the Herkomer estate in 1936.

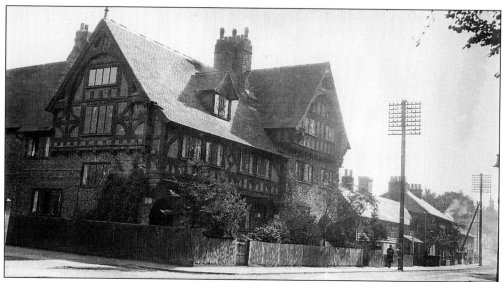

Herkomer had the buildings on the south corner of Melbourne Road erected in a pseudo-Bavarian style. They were occupied by his printer Henry Thomas Cox in Solon (the nearer part) and by Bushey College which taught the children of the many resident artists. The area beyond was called The Slads – a dialect word for a marshy place – and the Fishmongers Arms next door often flooded so that regulars stood at the bar in their wellingtons.

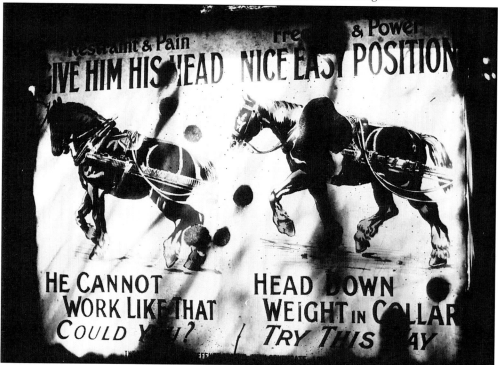

An enamel sign outside Meadow Studios at the foot of Clay Hill admonished carters and waggoners to be considerate to their horses. It was erected following a campaign conducted in the correspondence columns of The Times by the Cowderoy sisters. This sign was stolen in the 1970s, but a similar one, formerly at Bushey Arches, survives in Watford Museum.

Two

Around Bushey

The Lodge for Bushey Grange in Finch Lane, almost certainly in 1865. There was a fashion for the lodges of big houses to be made rustic and picturesque. There are a number of examples still surviving in this area, even though the big houses they served have long gone. Sadly, Bushey Grange Lodge has not survived.

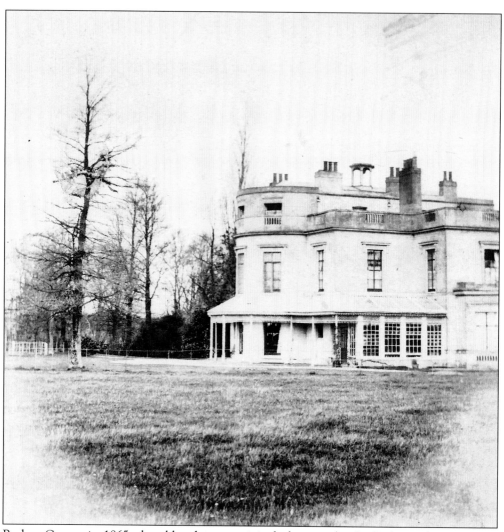

Bushey Grange in 1865, the oldest known original photograph of a Bushey subject. Bushey Grange estate lay between Finch Lane and Little Bushey Lane and the house itself was built around 1830. It was the home of the Burchell-Herne family for most of its life. The Reverend Humphrey Herne Butchell-Herne, an Anglican priest without a specific parish, was a major benefactor in Bushey affairs in the late Victorian and Edwardian period. The house was demolished in the late 1930s, although several of the estate's exotic trees remain in Finch Lane Fields.

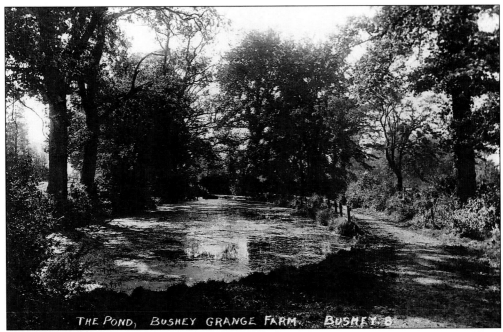

The Long Pond at Bushey Grange Farm, alongside the footpath to Little Bushey Lane in about 1920. The pond was much loved by children and ramblers and there was widespread sadness when it was filled in for greater agricultural efficiency in the 1960s.

The Burchell-Herne Cottages and barns at Bushey Grange Farm in about 1930. It was also known as Hedges' Farm after the last farmer to live there.

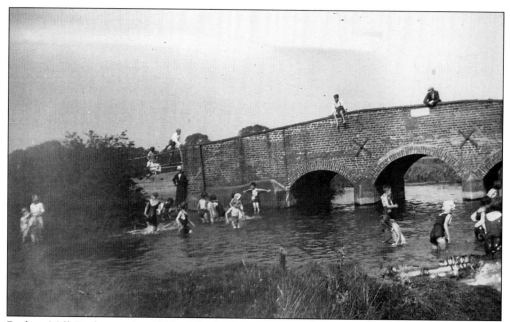

Bushey Mill Bridge in the 1920s. The bridge looks ancient but it actually dated from 1813, when it was rebuilt using materials from an earlier bridge which was 'decayed, out of repair and impassable'. This bridge was later replaced with a wider, more modern bridge, which in turn was replaced when the M1 Link, Stephenson Way, was built. The children have avoided paying to use the Bathing Place at the Five Arches, a little downstream.

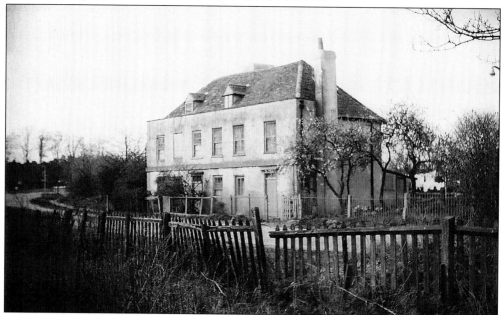

Bushey Mill Cottages in the 1960s. The Domesday Book in 1086 lists two mills in Bushey and at least one of them was on this site. It was originally a flour mill, but in its latter days it became a paper mill. It was a picturesque building, much drawn by artists until it was destroyed about 1830. The adjacent mill workers' cottages survived, albeit much altered, until the building of the M1 Link.

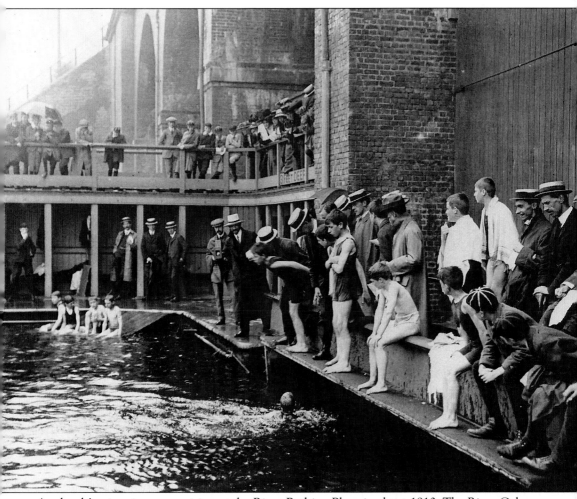

A schools' swimming competition at the River Bathing Place in about 1910. The River Colne at the Five Arches was a traditional bathing place for the people of Watford and Bushey. It was eventually provided with extensive changing areas and amenities by Watford Council although half of the site was in Bushey as the boundary ran down the middle of the river. The charge was 1d or 2d for mixed bathing! Its popularity declined with the opening of alternative purpose-built outdoor and indoor swimming pools and it was eventually closed in the mid-1930s. The site is now bereft of any sign of its former use and lies close to the M1 Link Road, Stephenson Way.

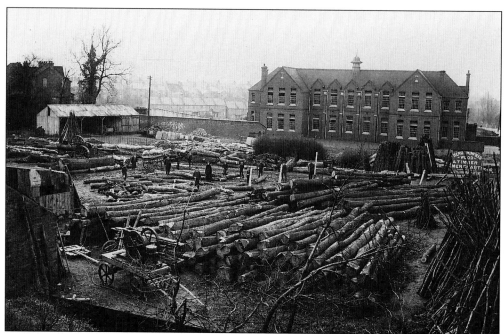

Henry Winfield's woodyard from Crook Log Cottages, looking toward London Road Schools. The Schools opened in 1907 as all-age elementary schools and eventually became Bushey Manor Junior School in the mid-1960s, before being later demolished to make way for the Health Centre, when a new Bushey Manor School was built in Grange Road.

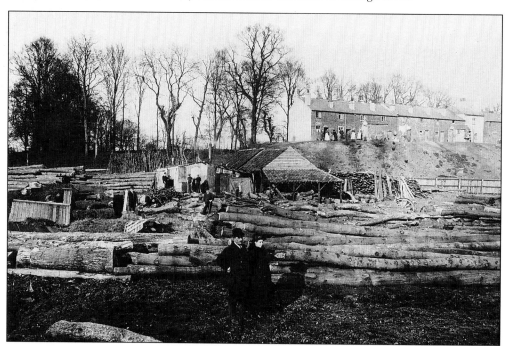

Mr & Mrs Henry Winfield in about 1910, standing in their woodyard, with Crook Log Cottages high up on the bank behind. The cottages had communal privies and their water supply was just one outside standpipe.

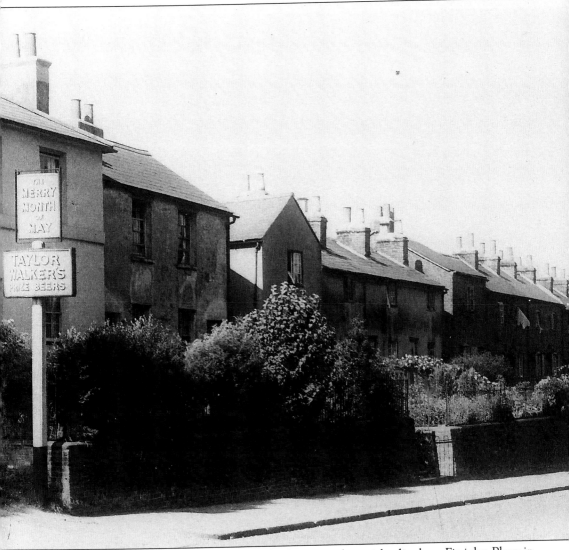

Crook Log cottages in London Road were also known rather misleadingly as Fitzjohn Place in the nineteenth century. They were tiny, had no mains services and were justly condemned by Bushey Council. They were originally built to house workers from the brickworks just behind them. The Merry Month of May beerhouse at the end of the row plied a small trade from about 1860 to 1960. This and its adjacent cottage are the only buildings to survive the clearance in the 1960s. London Road was widened and further lowered to reduce the gradient nearer Grange Road just before the Great War.

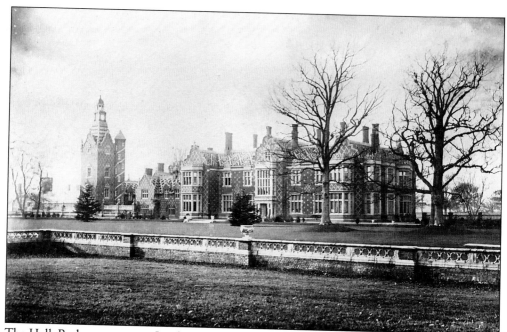

The Hall, Bushey, was a neo-Jacobean extravaganza built by Edward Marjoribanks of the family who owned Coutts Bank. It was built in 1865 on the site of Bushey Grove, the estate of which ran the length of Aldenham Road. The garden front in 1870 displays the spectacular diaper tiling and brickwork.

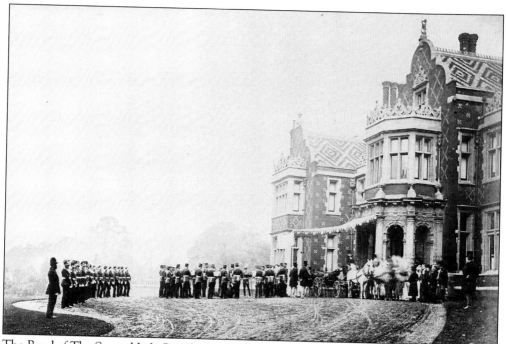

The Band of The Second Life Guards play outside Bushey Hall's front entrance on 16 October 1872, as Miss Georgiana Marjoribanks enters her carriage, to be driven to St James' Parish Church for her wedding to Edward Hanning Lee, an officer in Her Majesty's Life Guards.

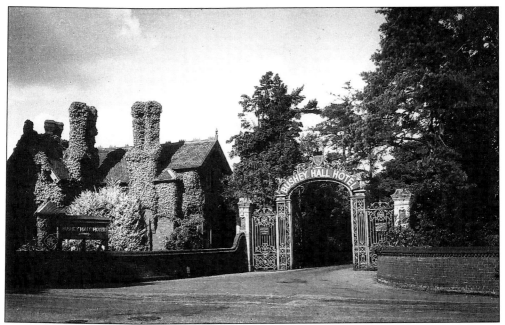

The debts Edward Marjoribanks incurred in building The Hall, forced him to put it up for sale in 1877. By 1883 it had become a hydrotherapeutic establishment for the then fashionable water cures and later became a grand country hotel known as Bushey Hall Hotel. The beautiful gates were taken for scrap during the Second World War, just after this picture was taken.

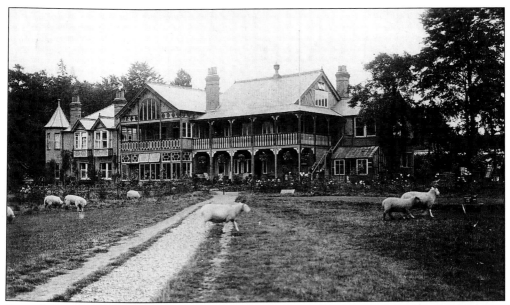

One of the attractions of the Bushey Hall 'hydro' was a small golf course which in 1890 became the West Herts Golf Club, the first in Hertfordshire. A full course was laid out in 1891. In 1897 a dispute with The Hall owners over Sunday play, led to the West Herts Club moving to Cassiobury and a new club was in due course formed at Bushey, where a fine new clubhouse was built. In 1913 the golfers still shared the course with sheep.

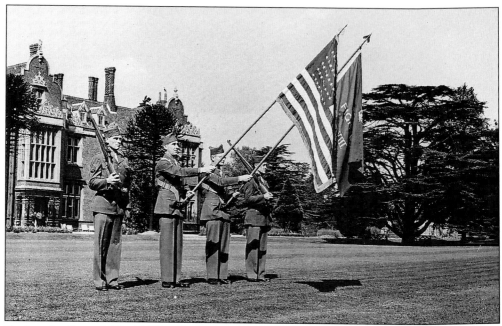

During the Second World War, Bushey Hall Hotel was requisitioned and from July 1942 to January 1945, was occupied by the United States Army Air Force. For much of that time it was the HQ of the Eighth Air Force Fighter Command, code-named Ajax. There was then and still is, a great deal of confusion with the Eighth Air Force HQ at Bush(e)y Park in Teddington, code-named Widewing.

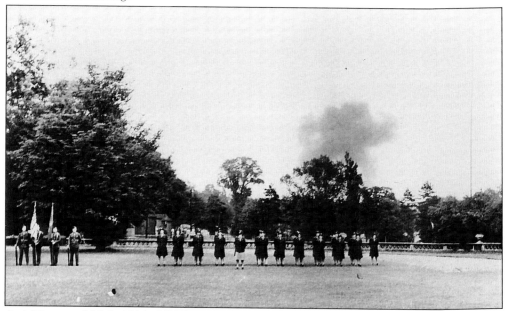

At 1.30 pm on 28 July 1944 a V1 Flying Bomb fell on the Moatfield. Over 600 houses in Bushey suffered blast damage, but miraculously, only six people and a goat were injured. At exactly the time the Flying Bomb exploded, a medal ceremony was being conducted on the terrace at Bushey Hall, but the WAACs did not move. The plume of smoke from the explosion rises above the trees.

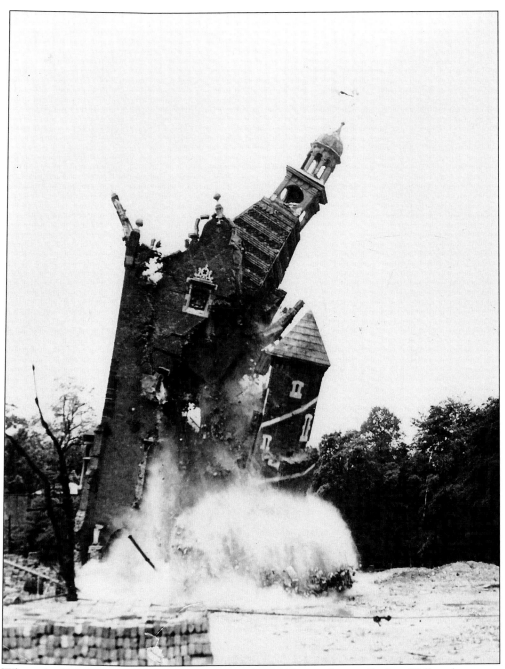

When the US Army Air Force left in 1945, the RAF moved in to Bushey Hall and set up a Transport Group HQ. They were very much concerned with the Berlin Airlift. By 1955, The Hall was dilapidated and there was no interest in such enormous and expensive to maintain mansions. After its demolition, the site was re-used by the US Forces as a school and it later became the Lincolnsfield Centre.

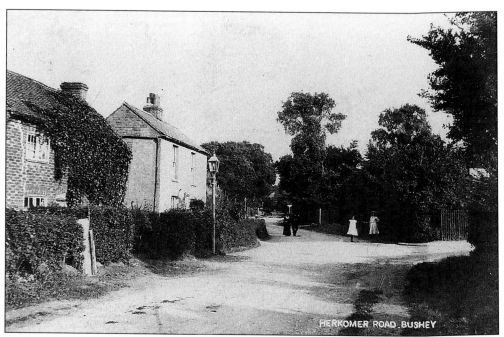

Herkomer Road in 1906, between Falconer Road and Glencoe Road. The couple strolling down the middle of the road would now be picking their way over the speed humps. The houses on the left, albeit somewhat modernised, still stand.

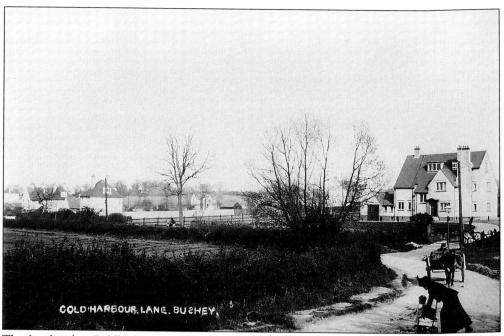

The first bend in Coldharbour Lane as from Melbourne Road. It was along the hedgerow on the left that Herkomer set his famous painting Hard Times. The first house in King George Avenue is in the middle distance, which dates the scene to around 1912.

Coldharbour Lane in the early 1920s was still a true lane. There are many roads and places called Coldharbour but the meaning is obscure. There is quite often a Roman connection and one explanation is that it describes a rough shelter for travellers. Coldharbour Lane connects two probably minor Roman roads and Roman remains have been found nearby.

Coldharbour Farm was one of the ancient farms of Bushey. It was often known as Green's Farm after the family who occupied it for many years and who supplied dairy products to their High Street shop. It was replaced by Ryder Close in 1966.

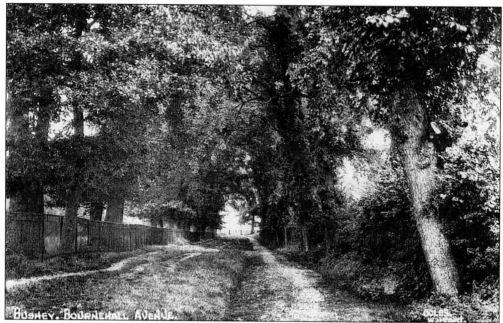

Bournehall Avenue was an ancient green lane leading to Solomons Wood, where Bournehall School now is. It was an extension of Bournehall Lane and Nightingale Lane, which still leads past the Moatfield behind the houses in Bourne Road. In the mid-1920s, the old Bournehall Avenue was joined up with Herkomer Road when the cottages on the Green where Goslett Court now is, began to be demolished.

Catsey Lane was another ancient green lane which formerly led through to Back Lane, now Herkomer Road. It gave access to the farmland between Sparrows Herne and Coldharbour Lane and proved very convenient when the King George Recreation Ground was laid out in about 1912.

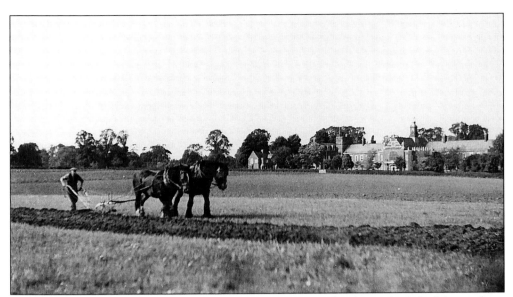

Farmer Hedges of Bushey Grange Farm in Little Bushey Lane ploughing where the Metropolitan Police Sports Club now is, in October 1936. The Royal Caledonian Schools are in the background.

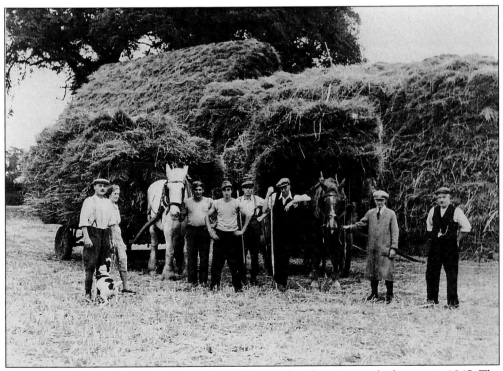

Farmer Hedges (on the left) with his wife and farmworkers bringing in the harvest in 1945. The brawny men in forage caps in the centre are POWs.

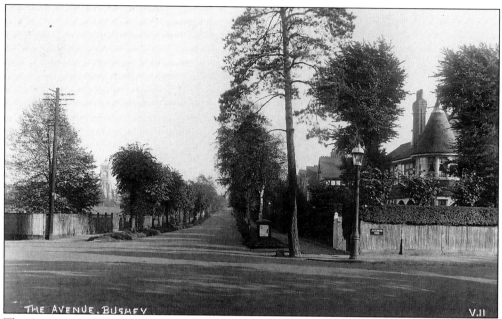

The Avenue in 1931 when the trees were only twenty-five years old and long before the rocky roundabout.

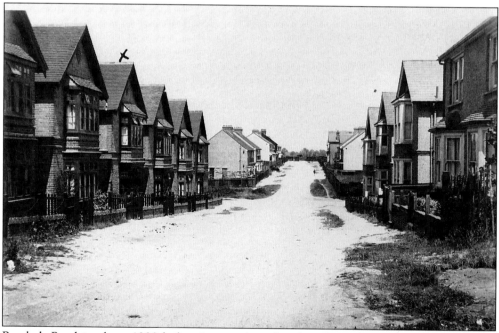

Bendysh Road in about 1930 before it was adopted and made up by Bushey Urban District Council.

50

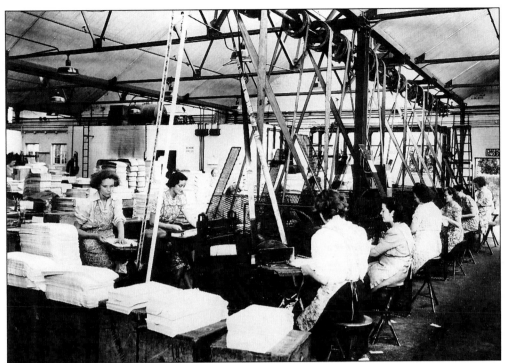

Brothers James and Frederick Ellam coined the word 'duplicator' in about 1892 to describe the flat-bed copier they had developed. They produced the first ever rotary copier in 1901 and their Company grew such that they moved into large premises in Bushey Hall Road in about 1919. By 1938 they had 50 branches all round the world and they became a Public Company in 1947. By 1965 they were even selling photocopiers, but in 1971 they merged with Ofrex and the new Company closed the Bushey premises. The girls are working in the Stencil Department in 1947.

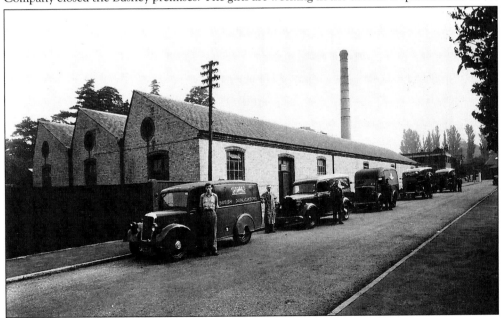

The Ellams transport fleet in 1947 lined up outside their Walton Road premises.

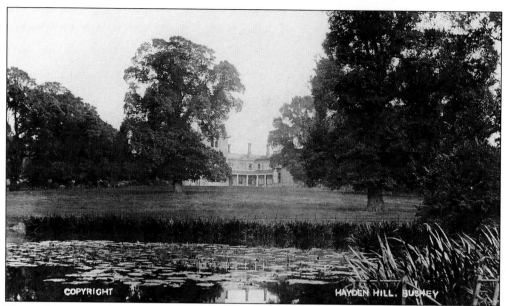

The architect Decimus Burton built an Italianate villa Haydon Hill House (mis-spelt 'Hayden' on the photograph) for Thomas Fonnereau in about 1840. It replaced Dr Thomas Monro's elaborately rustic country cottage. Robert Percy Attenborough bought the estate in 1872 and greatly enlarged the house but kept to the original style. It remained in the Attenborough family until 1940 when it was requisitioned and then, after some time as a local authority retirement home, it was converted into luxury apartments. The lake was originally very open, but is now much overgrown.

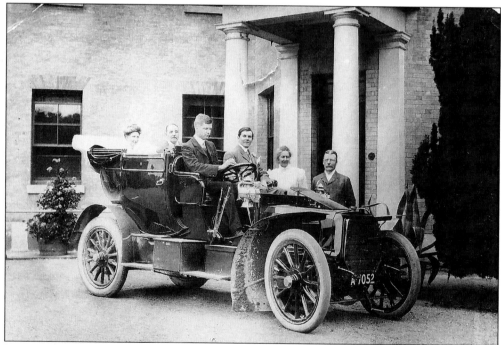

Laura and Robert Attenborough stand at the portico of Haydon Hill House as their son looks uncertainly at the controls of an unfamiliar car in about 1910.

Three

People

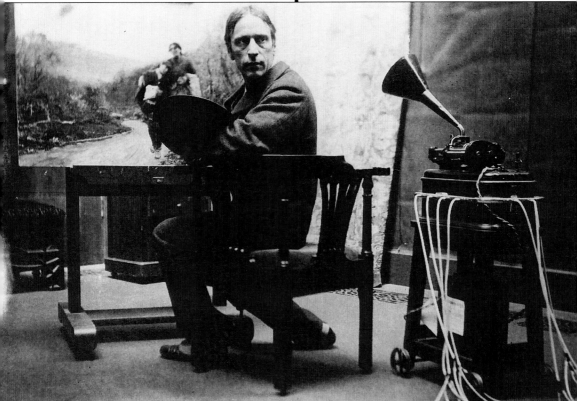

Hubert Herkomer (1849-1914), a poor immigrant from Bavaria, managed to support himself through a patchy art education and achieved some early success by drawing for The Graphic. In 1873 he settled in Bushey, near one of his first patrons. Although he eventually made his fortune through portraiture, he is best remembered today for his social realist paintings of the poor and destitute, such as The Nomads which he finished in 1894. He died Sir Hubert von Herkomer RA CVO with many foreign honours.

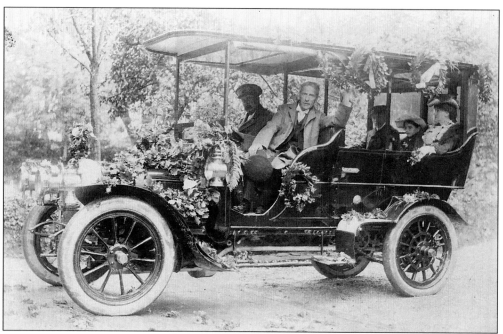

Hubert Herkomer married three times and had four children, but he has no surviving descendants. He was an enthusiastic motorist and inaugurated motor rallies in Bavaria. He enjoyed taking part in motor parades, but the subject of this one in about 1905 is not known. With him and his chauffeur are his third wife Margaret and their children, Gwynddedd and Lawrence.

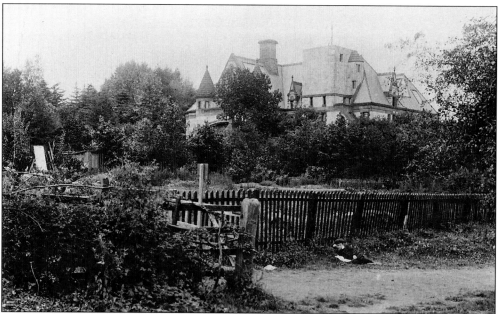

Herkomer's 'castle' Lululaund, named after his second wife, Lulu Griffiths, was built between 1888 and 1894 to exterior designs by H. H. Richardson, a distinguished American architect. It was built in Melbourne Road of Bavarian limestone tufa and Welsh red sandstone. It dominated the skyline of Bushey but had quite ordinary surroundings.

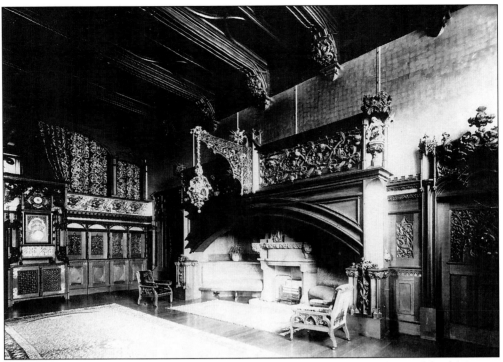

The interior of Lululaund was covered in the carvings of Herkomer's father and uncle, Lorenz and John. The salon chandelier had about twenty light bulbs powered by Bushey's first private generator.

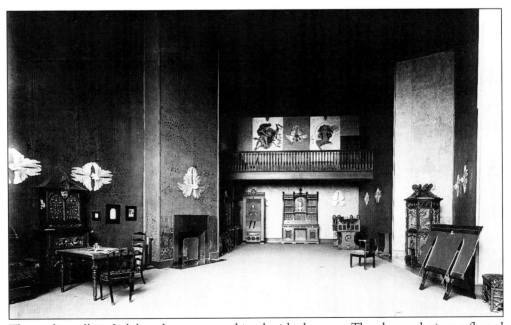

The studio walls in Lululaund were covered in planished copper. The clustered wings reflected the motto on the arms granted to Herkomer by the King of Bavaria: Propriis Alis, or, by my own wings.

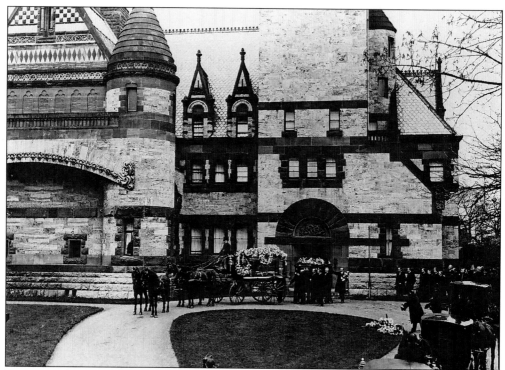

Herkomer died in March 1914 and was buried in Bushey parish churchyard. His pallbearers were all Royal Academicians and both the King and the Kaiser sent wreaths.

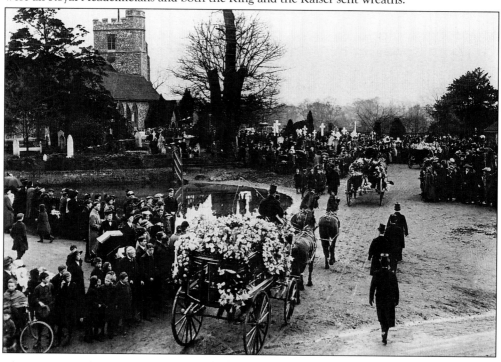

After lying derelict for fifteen years or so, in 1938 Lululaund was offered as a gift to Bushey Urban District Council to use as an arts centre. The Council turned it down in fear of its running costs and it was demolished the following year. Much of its masonry went as hard-core to build Bovingdon Airfield.

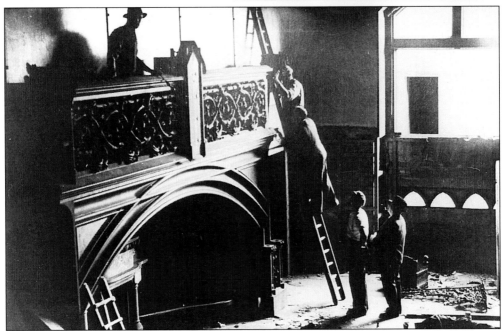

Much of Lululaund's magnificent carving was burnt, although the section above the fireplace is now in the Victoria & Albert Museum. The headmaster of the Royal Masonic rescued some for the School Chapel and a few other pieces can be seen in Bushey Museum.

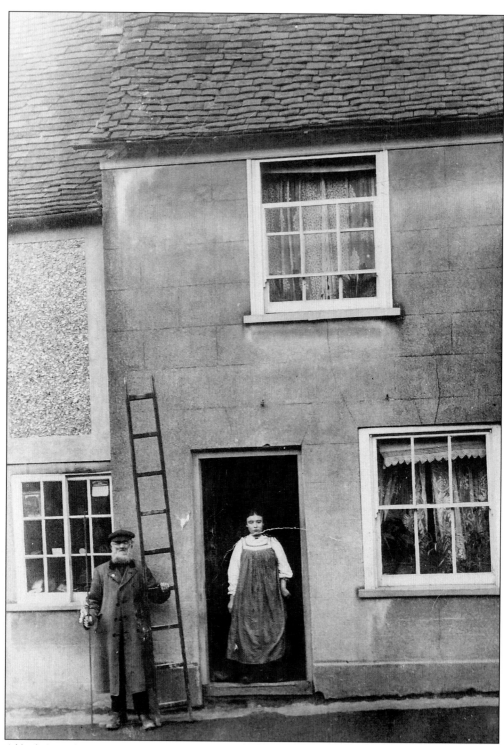

Alfred Grimshaw was the last lamplighter in Bushey. He is about to set off on his rounds in about 1905. He ran his cordwainer's (bootmaker's) business from the tiny room on the left of the front door of his cottage in the High Street.

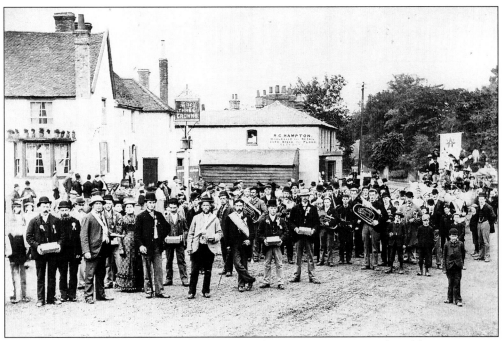

Bushey Heath Friendly Societies united in the early 1890s to mount parades and street concerts to raise money for Caldecot [sic] Hospital, a forerunner of Bushey Heath Cottage Hospital.

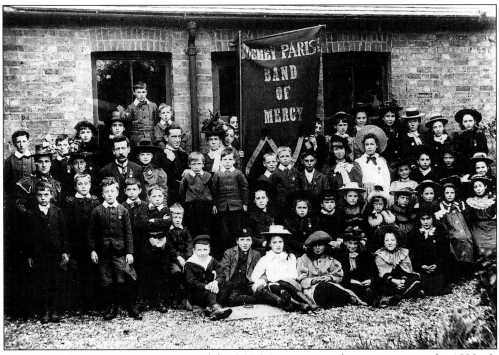

The Band of Mercy, a junior version of the RSPCA, was a popular movement in the 1890s. It campaigned against animal abuses in fashion such as the use of birds' wings in women's hats. Mr Morris and his three sisters ran the Bushey group in Falconer Hall.

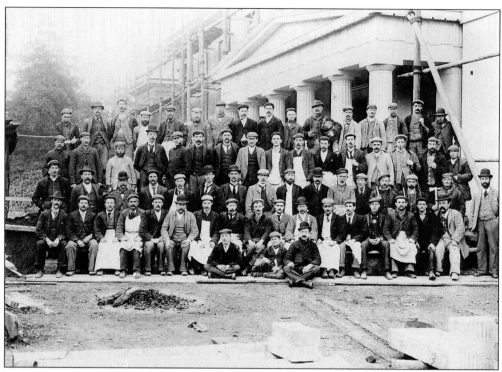

Bushey House was renovated and enlarged by E.H. Cuthbertson in about 1900. Nearly 70 tradesmen were working there at one time. The foremen can be identified by their bowler hats.

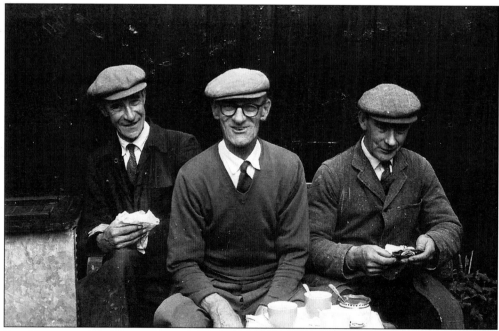

Jim, George and Bill Brockwell started their own building and decorating business in 1945. They had all worked for Field and Hemley before the War.

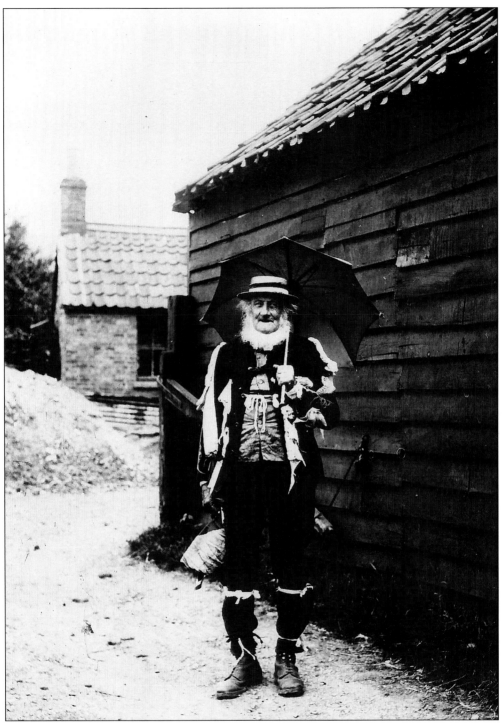

Johnny Bean Green, an eccentric member of the farming Green family, tied ribbons round himself on special days, particularly Oak Apple Day (29 May), and in later years kept them tied on all year round. He was a great favourite of the artists, including Herkomer, who published more than one portrait print of him in about 1910.

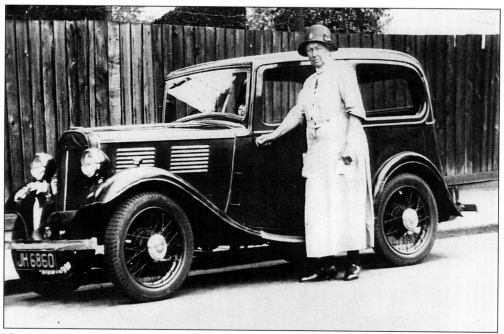

Nurse Reeves with her car in the 1920s. She lived at Flint Cottage in the High Street, the HQ of the Bushey Nursing Association. Nurse Reeves was the school nurse and harboured an abiding dislike of small boys.

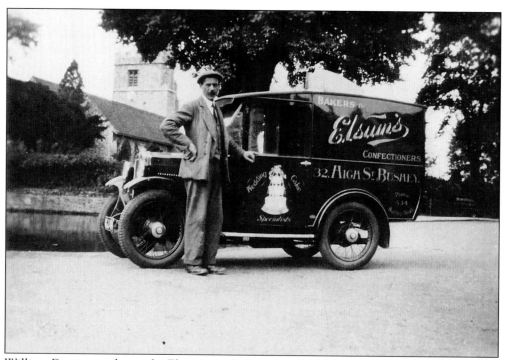

William Davis, roundsman for Elsum's, with their Austin 7 delivery van in about 1935. Carl Elsum took over from Corney's bakery and corn chandlery in about 1924.

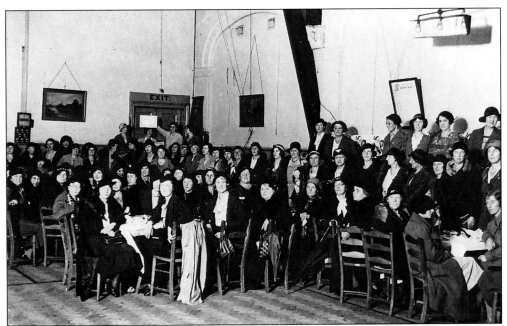

Bushey Townswomen's Guild in 1939 in Falconer Hall. Built in 1888, principally as a Sunday School for the parish church, Falconer Hall soon became the community hall for the village.

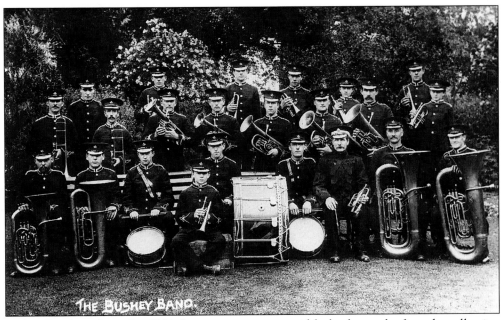

THE BUSHEY BAND.

Bushey Band was formed in 1911. Its instruments were paid for by the surplus from the collection made for the celebration of the Coronation of George V. It practised at London Road School three times a week and survived until 1924.

John Thomas Good and his wife Rosa, with their three daughters Violet, May and Lily in about 1890. Another daughter, Ivy, was born in 1893. John Good worked for the railway, but he and his wife also ran a horticultural nursery in Upper Paddock Road and an orchard in Bushey Grove Road. It was there that they developed the Bushey Grove apple which is a registered variety and is still grown in Bushey. A Bushey Grove Apple Cup is awarded annually by the Bushey Horticultural Society.

All eight Gillett boys, Ted, Arthur, Percy, Bill, Fred, Dick, Frank and Tom line up with Alice and Charles Gillett in about 1925. Gillett and Sons of Bournehall Road were builders and decorators. In 1939, five of the boys were in Bushey Fire Brigade together.

Henry Thomas Cox came to Bushey in the 1880s to be Herkomer's printer and later founded H.T. Cox and Sons, Fine Art Printers in Melbourne Road. Four of his and Priscilla's eleven children came into the business, which survived until 1970.

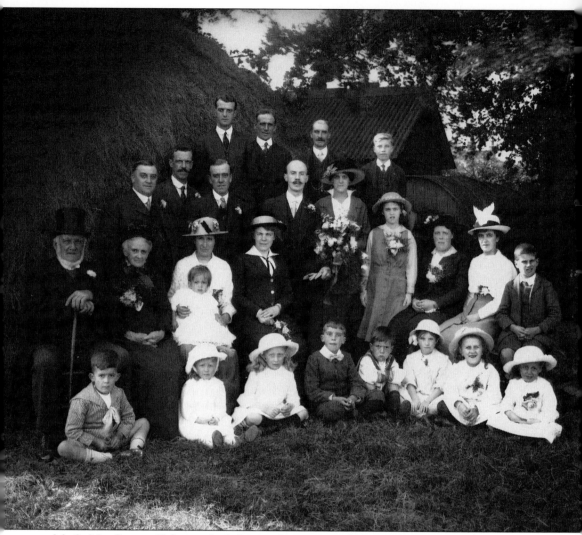

Mr & Mrs George Kirby on the left, preside over a wedding in the Kirby family. Not all the children seem pleased to be there. The setting is in the field behind the Kirby bakery in the High Road, Bushey Heath, near the Foresters Arms. Their delivery service developed into a transport service which ultimately became Kirby's Coaches.

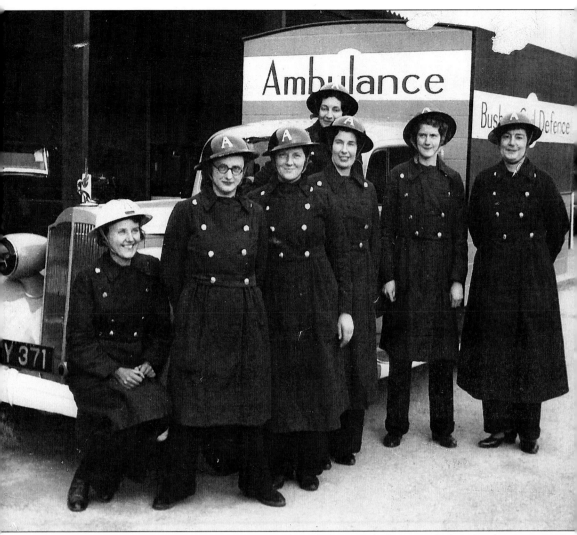

Lady Marjorie Stopford, on the left in the white helmet, led the two shifts of volunteer ambulance crews giving round-the-clock coverage at Bournehall Lane Depot in the early 1940s. The ambulance itself was a converted Packard bakery van.

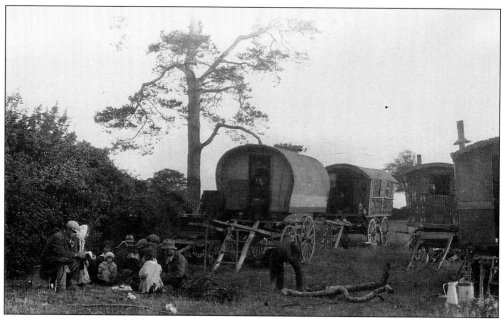

Gypsies and their vardo (caravans) were a common sight around Bushey in the Edwardian period. They would draw in and set up their benders in the country lanes such as Little Bushey Lane for a week or so and then be gone, as mysteriously as they came, without leaving behind the mess left by present-day travellers.

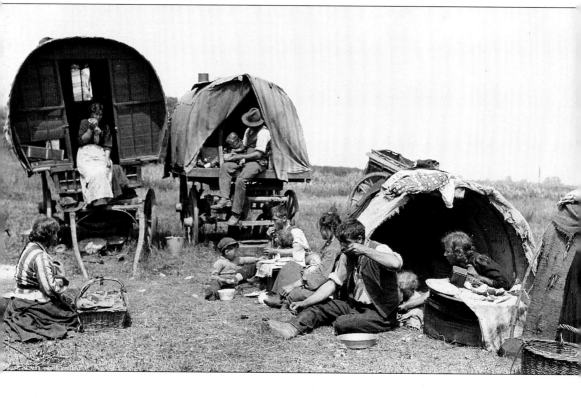

Four

Schools

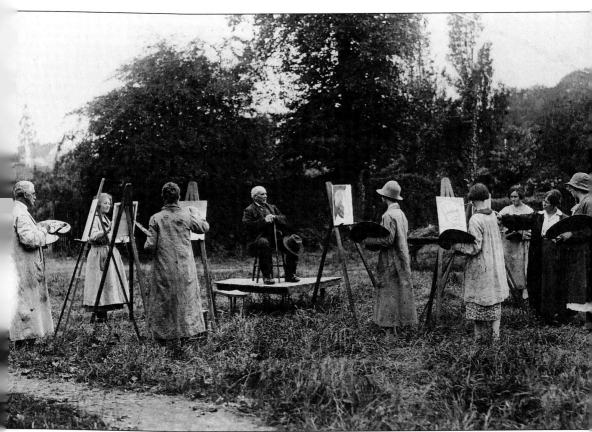

Lucy Kemp-Welch teaching a sketching class in her garden in 1926. Lucy took over the Herkomer School in 1905, after Herkomer's retirement. She renamed it the Bushey School of Painting and, when she moved it to her own premises, the Bushey School of Animal Painting. She gave up her School shortly after this photograph was taken and Marguerite Frobisher took it over, relocating it in Glencoe Road as the Frobisher School of Art.

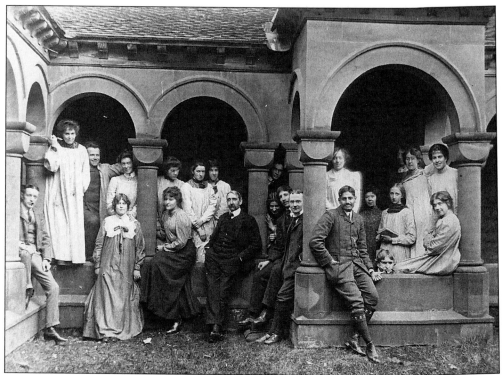

In 1883 Herkomer opened the Herkomer Art School in purpose-built studios, where the Rose Garden now is. The buildings were financed by Eccleston Gibb, Herkomer's neighbour and guardian of one of the first students, Annie Salter. Her father, George Salter, designed the School including the cloisters, a remnant of which can now be seen in the Rose Garden.

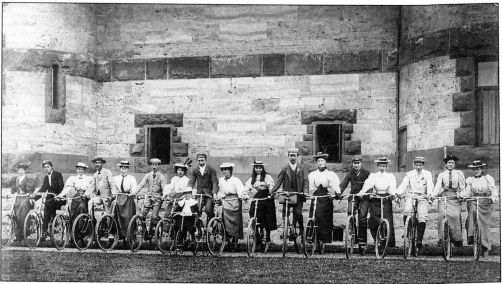

The Herkomer School Cycling Club assembled outside Lululaund in about 1897. The Herkomer School students enjoyed a range of extra-curricular activities including amateur dramatics, hockey, an orchestra and cycling, all encouraged by Herkomer who was himself a keen cyclist. The boy on the tricycle is Lawrence, Herkomer's second son.

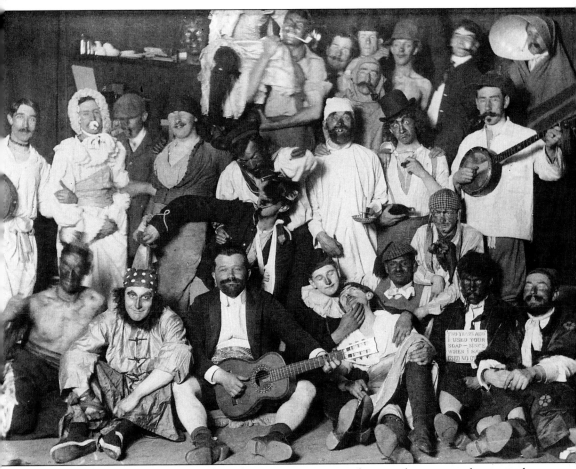

Although Herkomer encouraged students in sporting and musical activities he strongly disapproved of student capers. Parties were usually held when he was away and often in Meadow Studios, out of earshot of Lululaund, just in case.

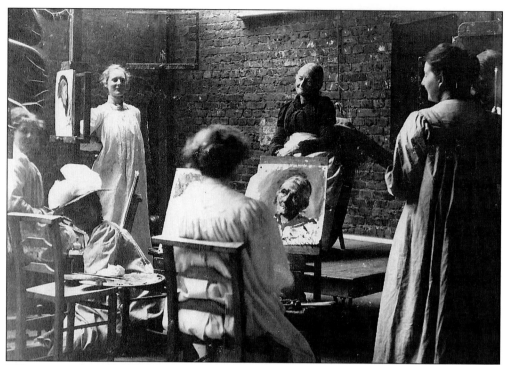

Villagers were hired by Herkomer students for 6d per hour to act as models for the Preliminary Class. Male and female students were allowed to work together in this class and the more fashion-conscious lady students wore smart smocks and kept their hats on.

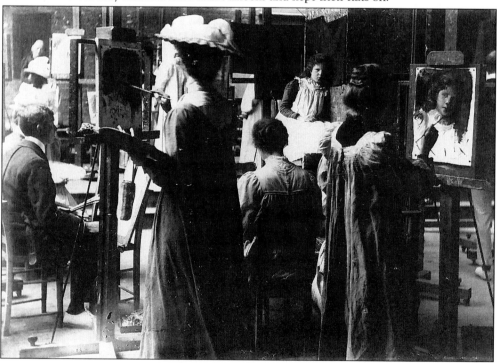

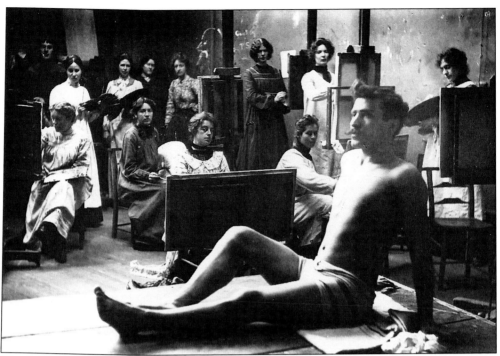

The Herkomer School Life Classes were strictly segregated, but Herkomer's teaching methods were progressive and he encouraged real talent in any form he found it. The actual oil sketch on the easel, from his 1901 class, has survived and can be seen in Bushey Museum.

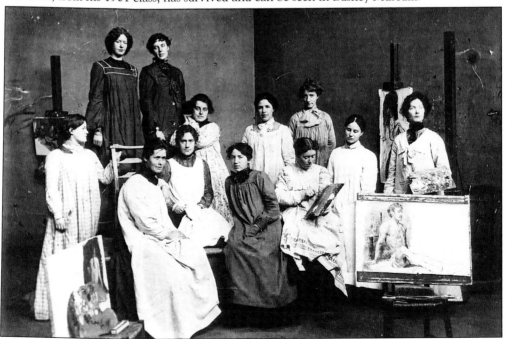

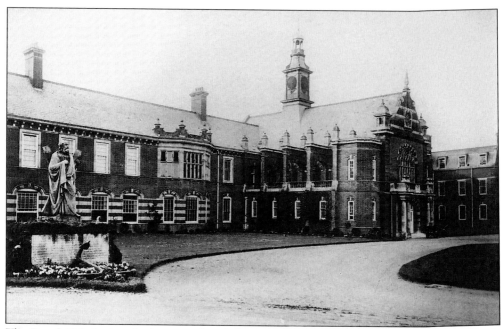

The Royal Caledonian Asylum was founded in 1815, became the Royal Caledonian Schools in 1852 and moved from Islington to Bushey in 1903. From 1947 until closure in 1996 the children who boarded at the 'Caley' were educated in local state schools. The superb hall and clock tower were destroyed in the last War. The Purcell School now occupies the building.

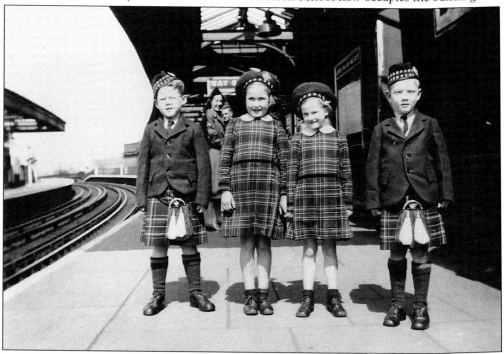

In 1944 the American servicemen and women at Bushey Hall befriended many of the 'Caley' children and took them on trips. These four are waiting on Bushey Station for a train to a London treat.

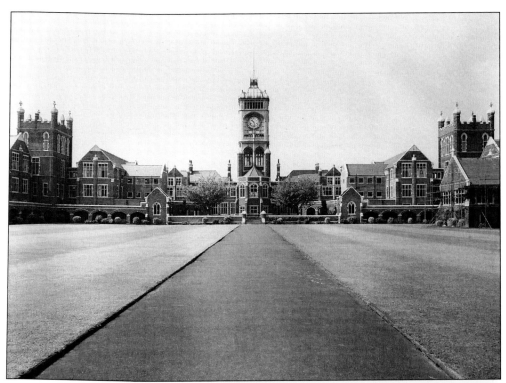

An unusual view of the Royal Masonic Senior School for Boys from the main quadrangle. The School was founded in 1798 and moved to Bushey in 1902. It was closed in 1977, following much controversy. The magnificent buildings enjoyed a brief continuation of educational use as the International University, the European campus of a private university based in San Diego, USA. They now await a new settled use.

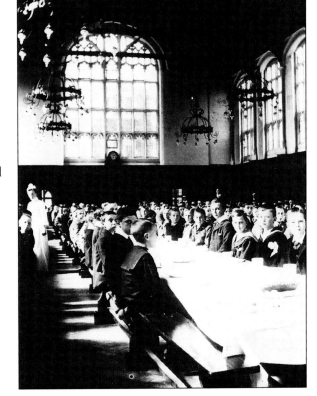

Royal Masonic boys in the refectory, soon after the move to Bushey. Although life at the boarding school was mostly austere, they were waited on at meal times.

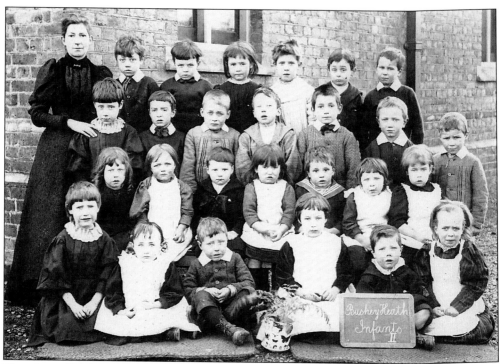

This class of Bushey Heath Infants in about 1900 seems seriously apprehensive of the camera. The School in The Rutts opened in 1879 with just two classrooms.

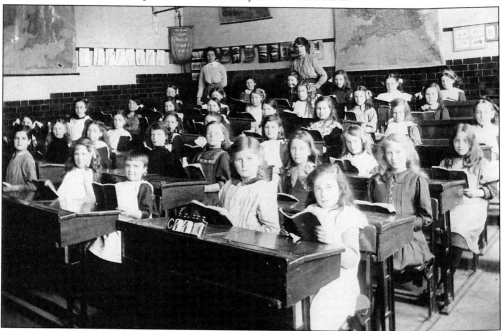

London Road Schools opened in 1907 as elementary schools for boys and girls with then modern raked classrooms. The banner at the back of this 1920 class was awarded each week to the class with the highest attendance. London Road became Bushey Manor in the mid-1960s and then moved to Grange Road as a Junior Mixed to make way for the Health Centre.

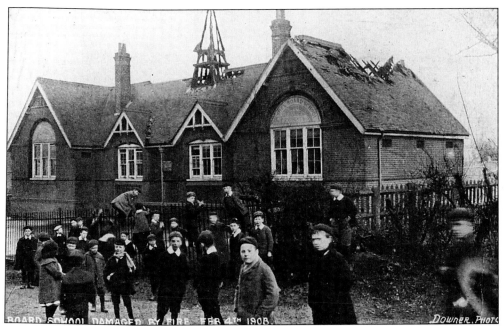

Mysteriously fire damaged classrooms at Merry Hill Infants and Girls School in School Lane in February 1908. It greatly distressed Mrs Mary Forsdyke who was the headmistress. The public garden at Bushey Heath is named after her.

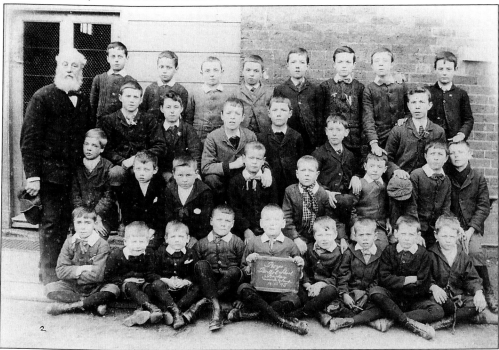

Edwin Bamford had been head of the Bushey British Boys' School for 39 years and was near retirement when his Second Group was photographed on 19 March 1895 – the earliest dated Bushey school photograph. The school was renamed Ashfield School in 1907. It celebrated its 150th anniversary in 1996.

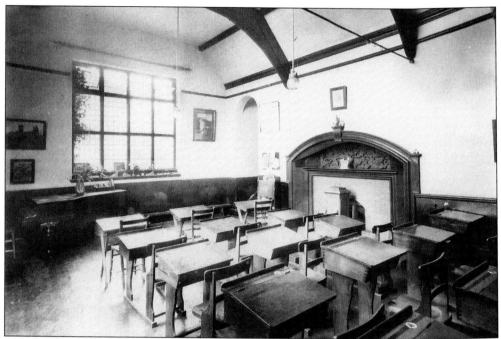

The schoolroom at 'little' St Hilda's at Bournemead in Herkomer Road in the early 1920s, where it had been since 1918. 'Big' St Hilda's opened in its present premises in the High Street in 1928. Miss Violet Curry had originally founded the PNEU school in Merry Hill Road. Bournemead had been built in the late 1890s as a studio-residence for a wealthy artist of the Herkomer School.

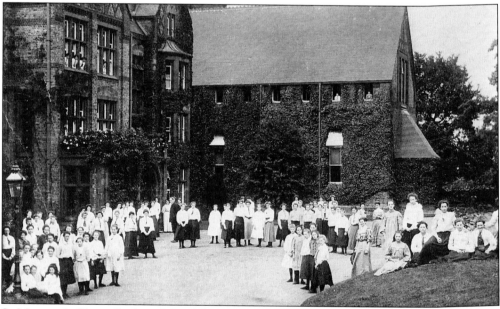

St Margaret's Clergy Orphan School for Girls moved from St John's Wood to Merry Hill in 1897 into new buildings by Alfred and Paul Waterhouse. By 1910 the rather severe buildings were softened by creepers. The School is still predominantly for boarders but now admits day girls as well.

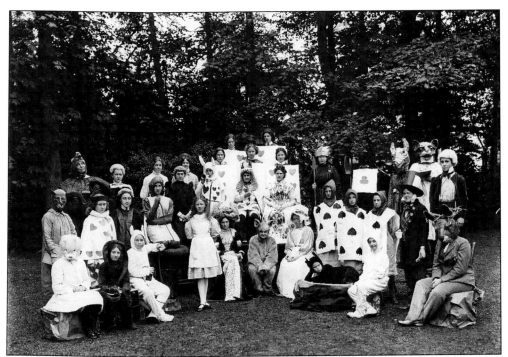

Caldecote Towers School was founded in 1891 by Miss Medina Griffiths who believed in the equal education of girls. Miss Tate and Miss Tanner took over in 1906 and they saw their task as to 'educate the daughters of gentlemen'. The School had a tradition of mounting beautifully costumed outdoor plays. *Alice* was produced in July 1910.

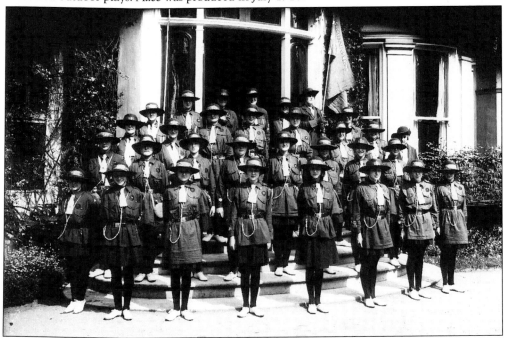

The 1st Caldecote Company of the Girl Guides, based at Caldecote Towers School, were very early in the Guiding movement. The date is uncertain but it could be about 1914.

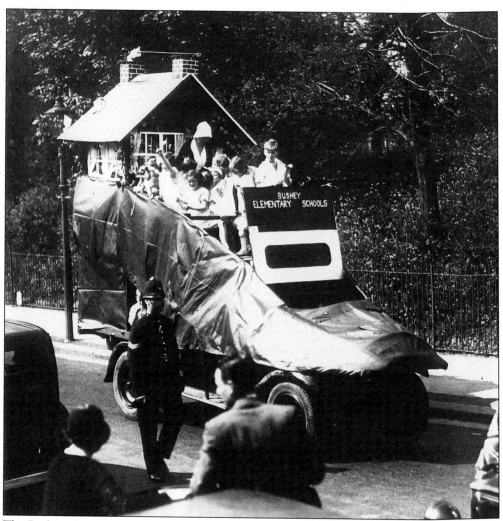

The Bushey elementary schools, Ashfield, Merry Hill and London Road, got together to build The Old Woman Who lived in a Shoe float for the 1935 parade and pageant to celebrate the Silver Jubilee of the reign of George V.

Five

Services

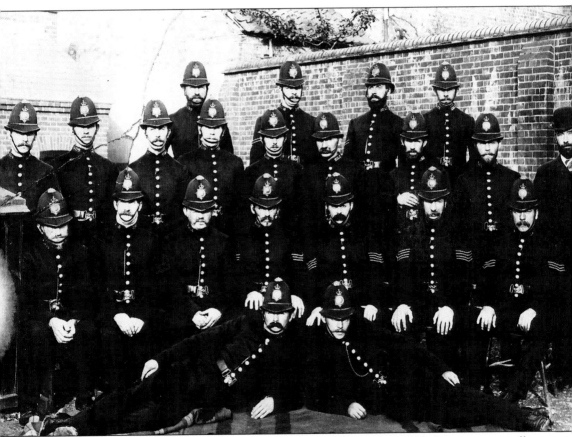

Bushey policemen in their Clay Hill station yard on 29 September 1893. It was not actually compulsory to have a moustache, but no officer has failed to grow one. Bushey is just inside the Metropolitan Police area and its first police station at 26 High Street, opened in 1840, bears a blue plaque commemorating the fact that it is the oldest surviving former Metropolitan Police building. The new police station opened in May 1884.

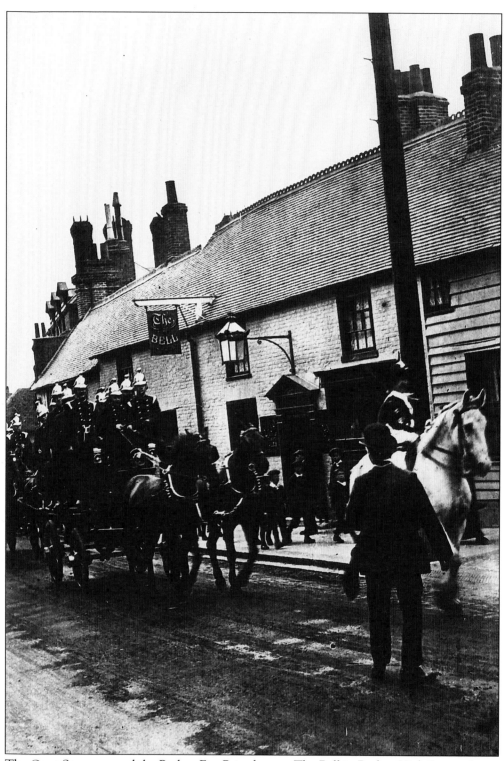

The Great Stanmore and the Bushey Fire Brigades pass The Bell in Bushey High Street after a services' church parade in 1914.

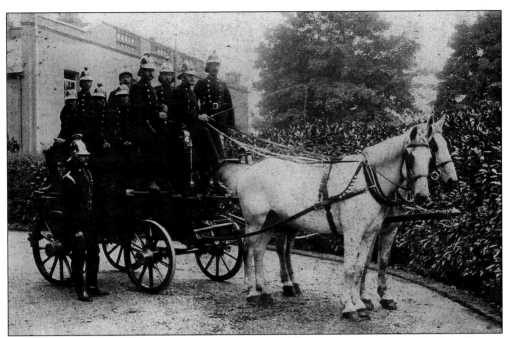

The Bushey Fire Brigade with their Captain, Major J.P. Somers, outside Hartsbourne Grange in about 1910. The horse manual was purchased second-hand for £90 in 1902. The horses were hired and had to be found and brought to the manual when the alarm sounded.

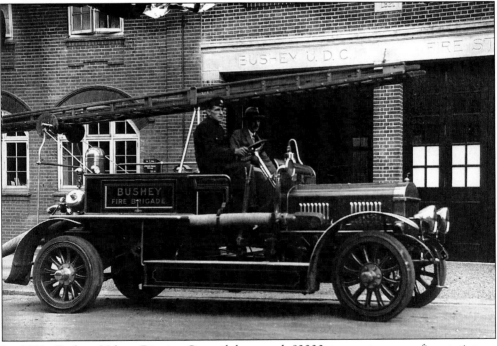

In 1921, Bushey Urban District Council borrowed £3330 to erect a new fire station as an extension to the Council Offices in Rudolph Road and to purchase Frederic [sic], a new Merryweather motor fire engine. The Captain was Mr Ernest Ryder, the Council Surveyor and Inspector of Nuisances.

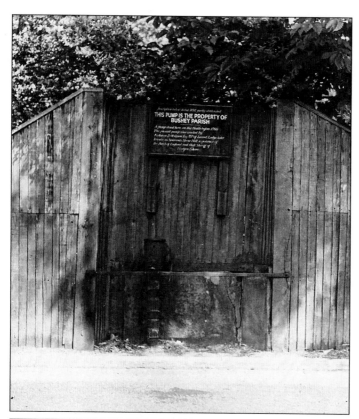

A well with some form of pump had served Bushey Heath residents on this site in Elstree Road for many years, but Mr Kirkman D. Hodgson of Laurel Lodge (later Sparrows Herne Hall) gave this new pump to the 'inhabitants of Bushey Heath' in 1850. It was the only public water supply in Bushey Heath until 1875.

The springhole in Sparrows Herne nearly opposite the Library, provided a trickle of water to local people. In dry weather it could take half an hour to fill a kettle.

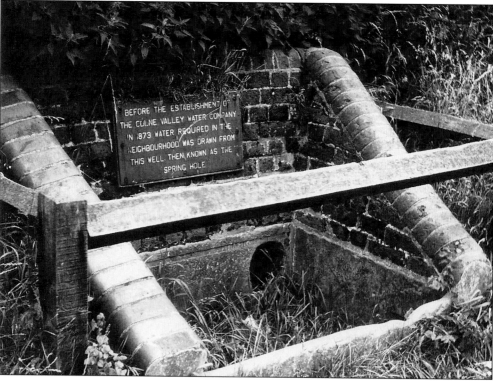

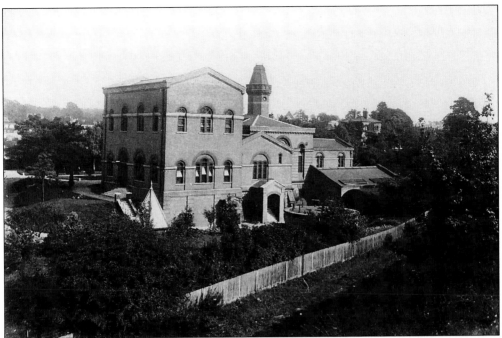

The pumping engine house at the Colne Valley Water Company works in Aldenham Road in about 1900. The Company was set up by Act of Parliament in 1873 following another serious outbreak of typhoid in Bushey. In 1875 deep wells were sunk into the chalk beneath the Colne Valley and the water was pumped up to covered reservoirs in Bushey Heath from where the mains distributed it.

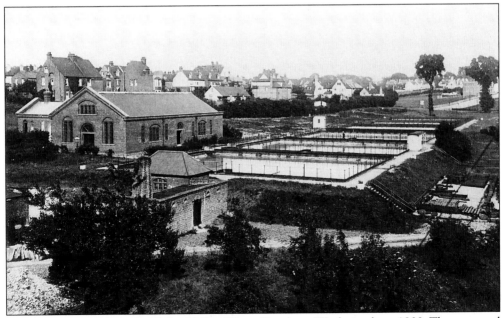

The depositing tanks at the Colne Valley Water Company Works in about 1900. The new road on the upper right is Hillside Road and the houses on the upper left are in Beechcroft Road.

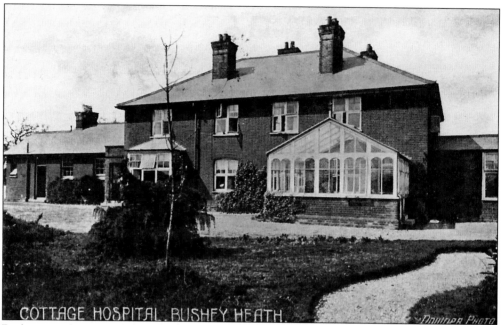

Bushey Heath Cottage Hospital opened in Windmill Street in 1898. It served an area which included Mill Hill and Ruislip, although it had only 20 beds. The weekly charge was 3/6d. It was absorbed by the NHS in 1948 and its independent functions were pared away in the 1970s and '80s, when it became a Care Centre for the elderly. It finally closed and was demolished in 1991.

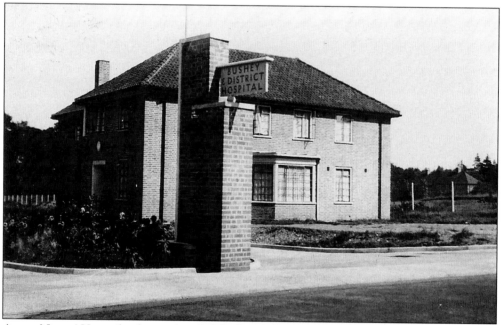

A new Nurses' Home for the newly titled Bushey & District Hospital was opened in 1937, paid for largely by public subscriptions. It was said that 'Matron's little family can live in a luxury that few can boast of under the paternal roof'. There were 12 bedsitters with separate communal rooms for each nursing grade. A maid provided tea and other services.

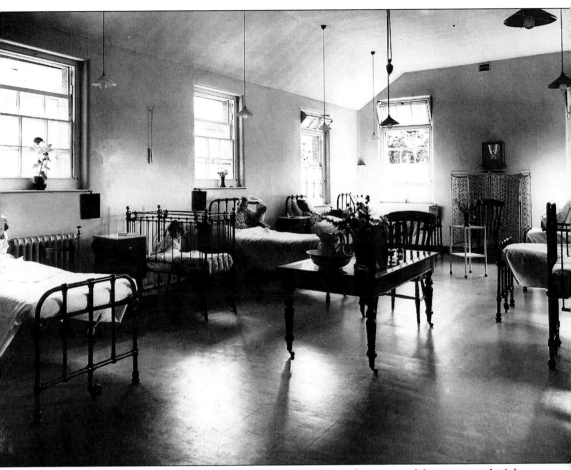

Before 1936, child patients in Bushey Heath Cottage Hospital were cared for at one end of the Women's Ward. In 1937, a new 14 bed Children's Ward was built with a covered verandah onto which the beds were wheeled on fine days.

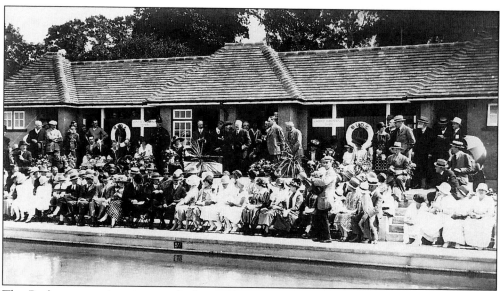

The Bushey open air swimming baths in King George Recreation Ground were opened on 11 July 1925 when over 1500 people crowded in to hear Mrs Mellor, wife of the Chairman of Bushey UDC, recall the alarming discovery of how unfit men were when they were recruited for the Great War. She advised children to use the bath, as 'he who controls his muscles, controls his mind'.

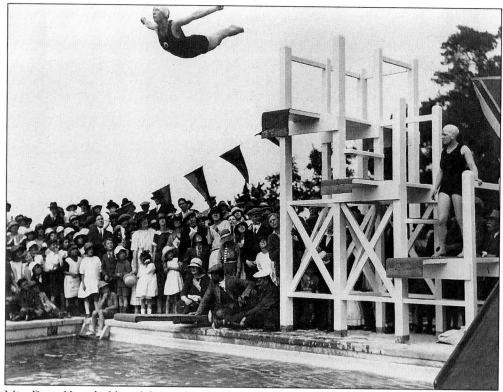

Miss Doris Hart, holder of the world record for 100m breaststroke gave a demonstration swim and members of the British 1924 Olympic diving team showed off their skills.

Six

Celebrations

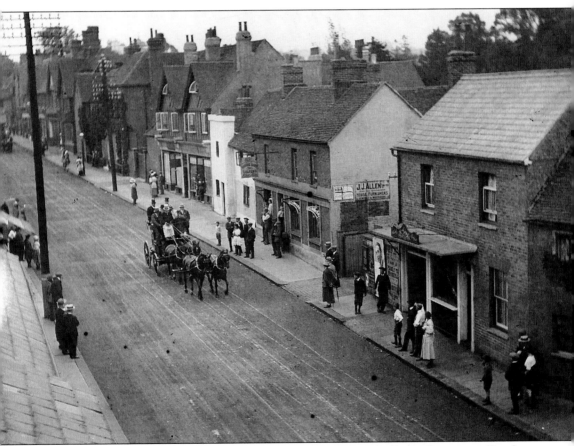

Watford celebrated the granting of a Charter to its Corporation for Borough status in October 1922. The Royal Charter was taken through Bushey in a procession which included a number of historic vehicles, including several mail coaches. The Charter was handed over to the Charter Mayor, the Earl of Clarendon, at the Watford border at Haydon Road.

The Coronation of George V took place on 23 June 1911. The principal celebrations in Bushey were a carnival and bonfire. 'Escorted by hundreds of spectators and throngs of children, a procession headed by the London Military Band headed for the Merry Hill field. Members of the Urban District Council and members of local Friendly Societies carrying banners – the United Patriots, the Oddfellows, the Foresters, the Rechabites and the Church of England Benefit Society all took part. Children each possessing tickets for the roundabouts and swings raided these merrymakers. About 4 o'clock, the juveniles were presented with souvenir mugs to use at their tea, the menu for which included ½lb of cake each and packets of sweets.' There were races including a Ladies Potato Race and a Ladies Threadneedle Race. Mr G. Wells won the marathon race round Bushey. 'Mr E.H. Cuthbertson lit the bonfire at 10 o'clock. The mounting flames added their noise to the cheers and joviality of the spectators. Dancing was vigorously kept up'.

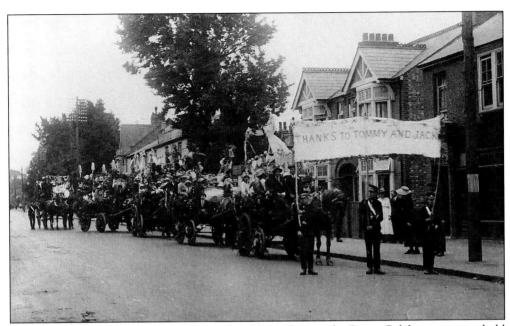

Armistice for the Great War was declared in November, so the Peace Celebrations were held over to July 1919. Bushey Heath's contingent in the Peace Parade assembled by the old Coach & Horses. Five decorated waggons carry the Bushey Heath Infants School children. They are led by a banner thanking Tommy Atkins and Jack Tar.

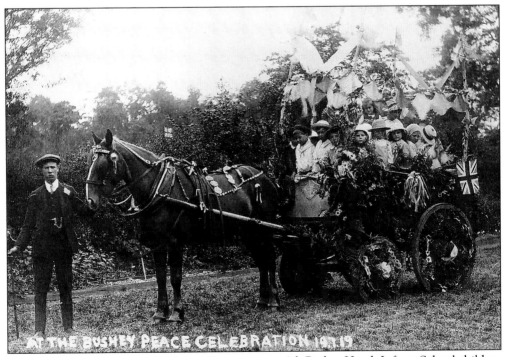

Percy Payne aged 17 leads a Caldecote Farm waggon with Bushey Heath Infants School children aboard, on their way to join the Peace Parade in 1919.

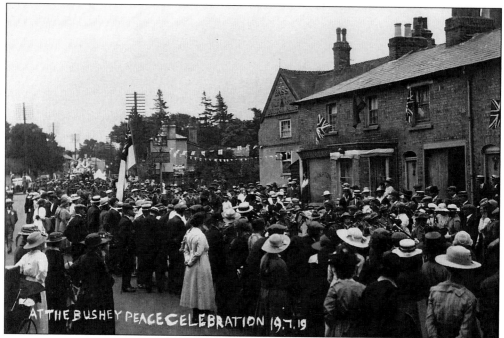

At the Bushey Peace Celebration 19.7.19

Virtually the whole population of Bushey Heath and Bushey turned out to watch the Peace Parade. A small body of sailors headed by Lt. Cdr. Tilly led the service contingent. Major Stoward MC was at the head of 150 soldiers from many regiments. The parade marches past The Three Crowns and Hampton's Bakery.

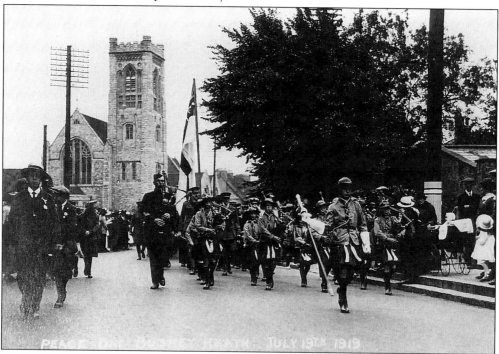

Peace Day Bushey Heath July 19th 1919

The pipe band from the Royal Caledonian School, unusually dressed in Scout uniform, lead the Peace Parade. They are passing The Elms, where the Synagogue now is.

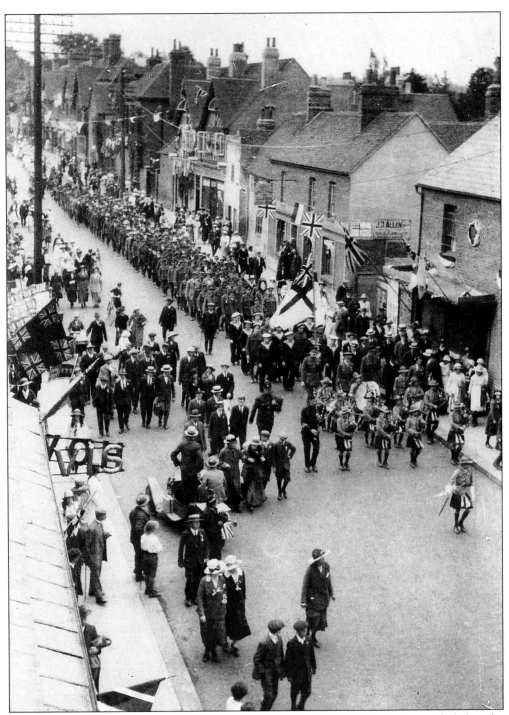

The 1919 Peace Parade marches past the White Hart in the High Street. It concluded at the Cricket Field in the Manor House grounds off Falconer Road. There were sports and sideshows and at 4 pm the children were given a bread and butter tea, finished with a bag each of cakes and buns. Later about 1,000 people 'sat down to a meat tea served in the big tent'. The Band of 1st Life Guards arrived in the evening to play for dancing and there was a bonfire and fireworks.

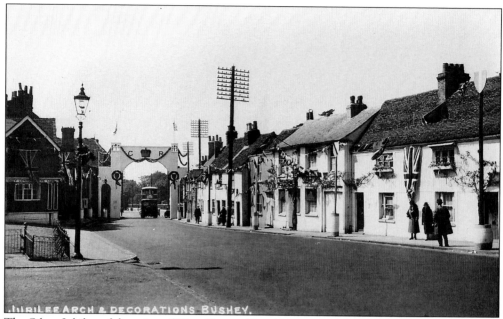

The Silver Jubilee of the reign of King George V in 1935 was celebrated with much enthusiasm in Bushey. Great archways designed by Lucy Kemp-Welch were built over the High Street near Falconer Road and near Melbourne Road. There were protests when they were later dismantled, even though they were only made out of plywood and scaffolding.

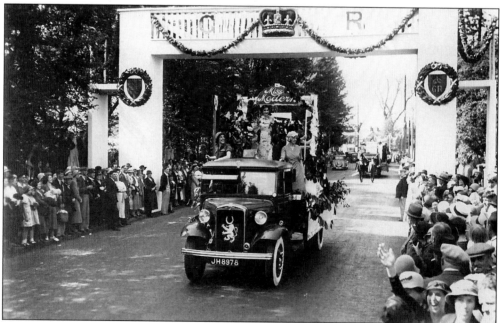

On 6 May 1935 the Jubilee procession wound round the Village and finished with a pageant, carnival and funfair in Lord Bethell's park at Bushey House.

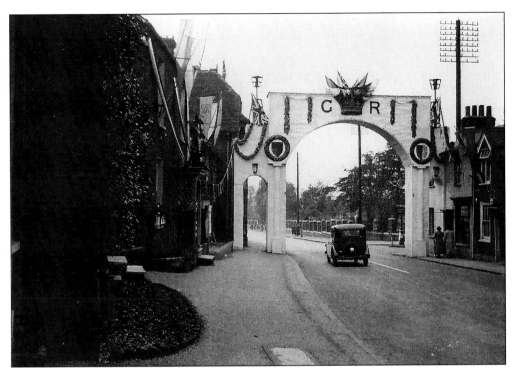

The Coronation of George VI in 1937 was celebrated by two more arches over the High Street, again designed by Lucy Kemp-Welch. There was no procession this time, but a Historical Pageant was prepared for the occasion to be performed by nine local schools. It was to have taken place on 12 May 1937 in Bushey House park, but torrential rain on the day forced it to be transferred to the great hall in the Royal Masonic Senior School for Boys.

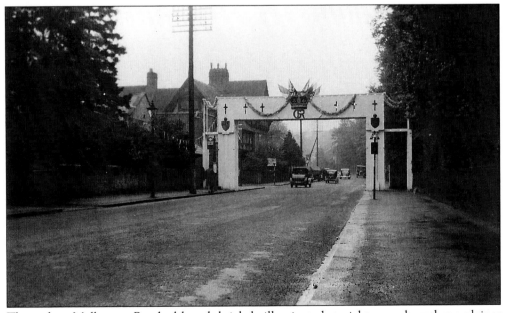

The arch at Melbourne Road, although brightly illuminated at night, was altogether a plainer affair.

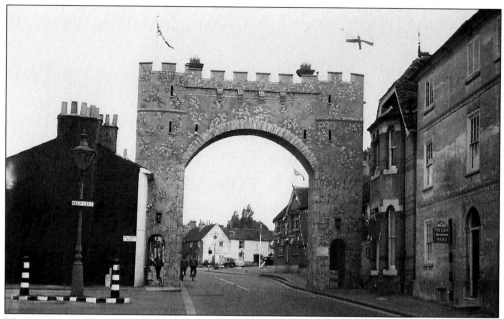

The Coronation of Elizabeth II in 1953 was celebrated by another arch designed by Lucy Kemp-Welch, but only at the Falconer Road end of the High Street. It stood from June to October and again there were protests, particularly from visitors, when it was removed, as they thought it had been real. Much of the material was used to build the Scout hut in Little Bushey Lane.

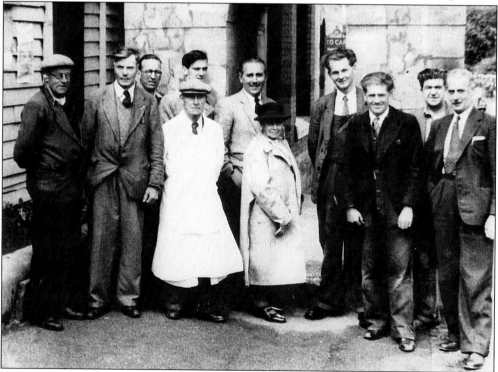

Lucy Kemp-Welch at 84 is standing surrounded by the staff of Field and Hemley who erected the arch and an unknown student (fourth from the left at the back) who painted it.

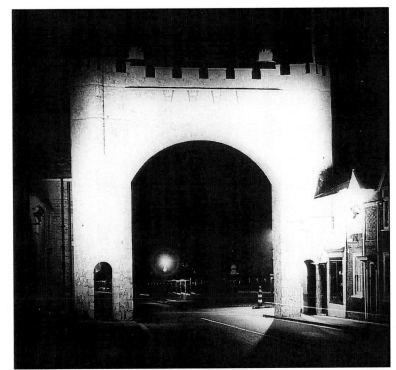

The 1953 Coronation arch was floodlit at night, one of the first ostentatious extravagances in Bushey after the War. The floodlighting emphasises the arch's dominance over the tiny shop of Mrs Middleton which sold china and toys.

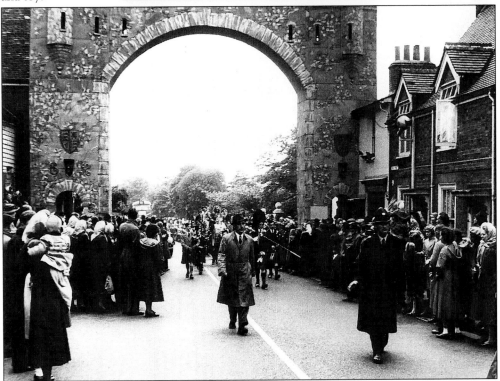

The day of the Coronation on 6 June 1953 was cold and sometimes wet. The band of the Royal Caledonian Schools leads a shivering procession of floats toward Bushey House park.

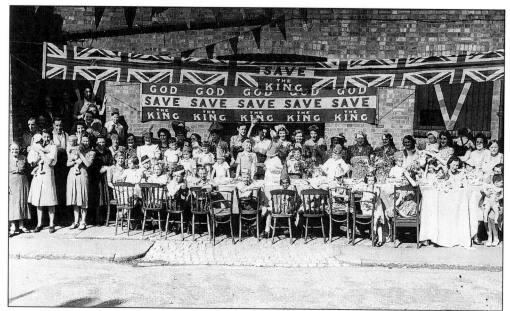

The end of the Second World War in May 1945 was celebrated with VE parties all over Bushey, as elsewhere. Vale Road is right on the border of Bushey with Watford and the residents had their party on the Bushey side.

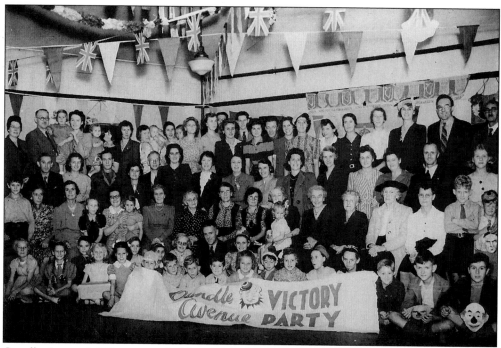

Oundle Avenue's VE party was held in the Co-op Hall above the shop in the High Street.

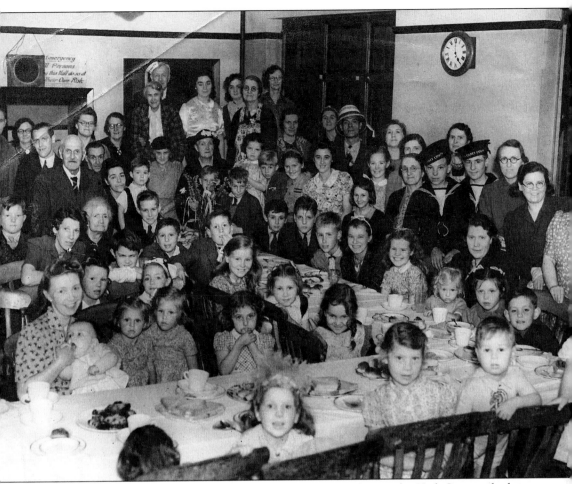

Park Road also had its VE Party in the Co-op Hall above the shop in the High Street, which is now Bordeaux Direct.

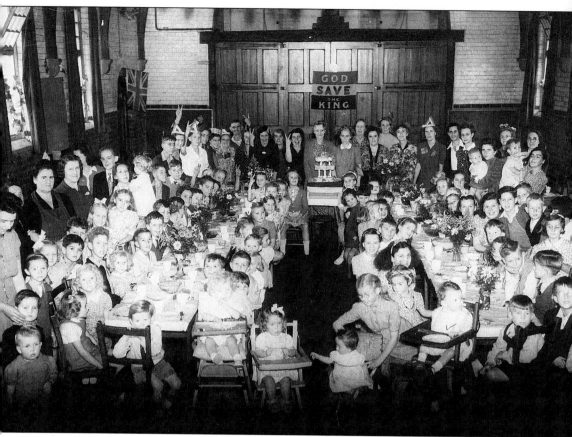

One School Lane VE Party was held in St Christopher's Mission Hall in Police Station Lane. The Hall had been built in 1898 by St Peter's parish to serve the School Lane area. It was used as a church, a Sunday school, a community hall and as an overflow classroom for Ashfield and Merry Hill Schools. Ashfield School dinners were served in St Christopher's Hall for many years. When it was eventually de-consecrated, it became a synagogue and is now much altered as Grosvenor House offices.

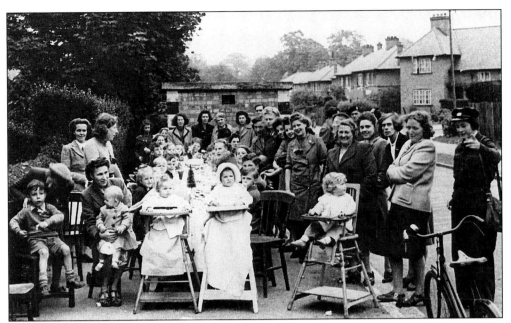

One of the Herne Road VE parties was held in front of the street shelter.

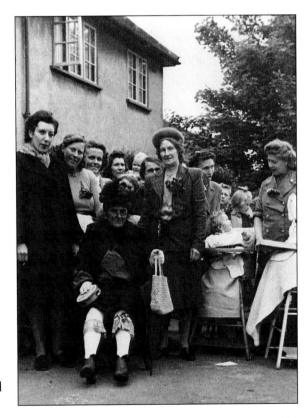

During the course of the Herne Road VE party, Old Mother Riley and her daughter Kitty seemed to have turned up!

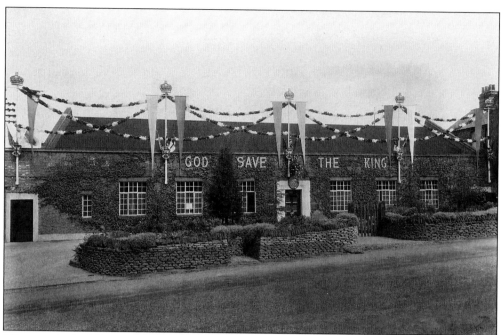

Ellams main building in Bushey Hall Road proclaims loyal greetings to King George VI and Queen Elizabeth on their coronation in 1937.

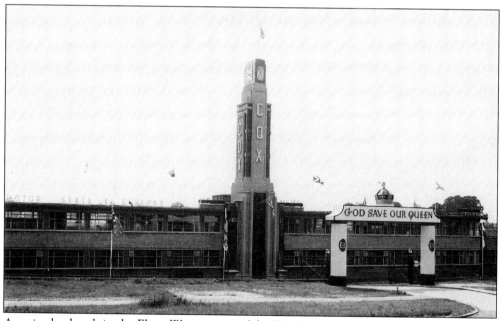

A major landmark in the Elton Way section of the Watford Bypass was Cox's Factory with its art deco tower. The Company moved to Bushey in 1937 and at one time made over one million car seats a year. During the Second World War they made aircraft parts and also dummy tanks and ships. After the war they made ejector seats. The Company was eventually bought out by Tube Investments and closed down. Costco occupies the site where, in 1953, Cox's proclaimed good wishes to the new Queen Elizabeth.

BUSHEY MUSEUM
AND ART GALLERY

Thank you for you order

With compliments

Rudolph Road Bushey Hertfordshire WD23 3HW
Telephone 020 8420 4057 Stewards 020 8950 3233 Fax 020 8420 4923
E-mail busmt@bushey.org.uk Website www.busheymuseum.org
Bushey Museum is a registered charity (294261)

Seven

Sparrows Herne

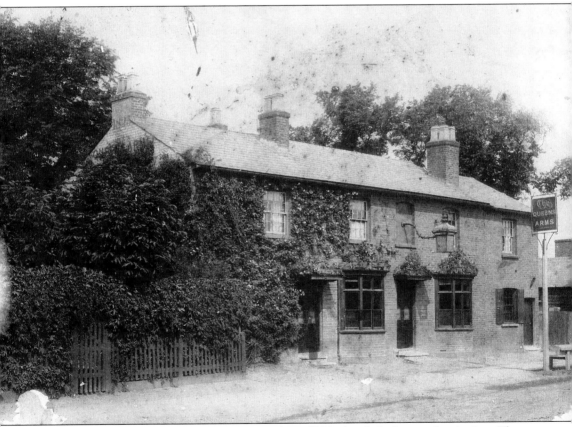

The old Queens Arms in Sparrows Herne in about 1920, shortly before modernisation. There are eighteenth-century records of a beerhouse on this site and, for most of the nineteenth century, it doubled as a wheelwright's business. The horse trough next to the sign was well placed, as it was at the Queens Arms that the extra waggon horses hired from the Horse and Chains, were unhitched and sent back down Clay Hill.

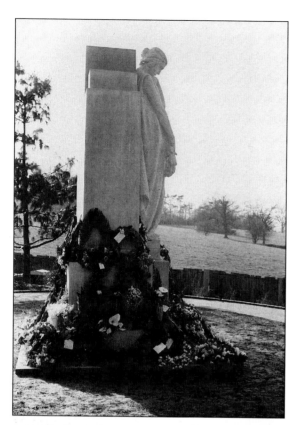

A symbol of sorrow at the junction of Sparrows Herne and School Lane mourns the Bushey dead of two World Wars. Sculpted by Sir William Reid Dick RA, it was dedicated in 1922, before the lower part of School Lane and Chestnut Rise were developed.

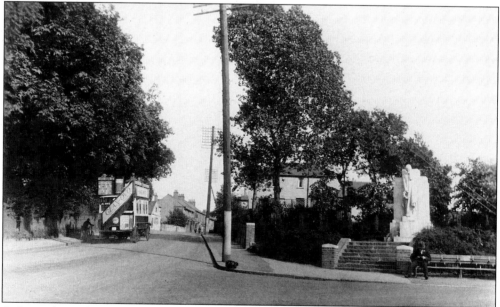

A General omnibus on the 158 route to South Harrow toils up the Clay Hill section of Sparrows Herne in about 1925. In bad weather, passengers were sometimes asked to alight and walk up the hill, while the conductor walked behind the bus with a chock on a pole, in case it rolled backwards.

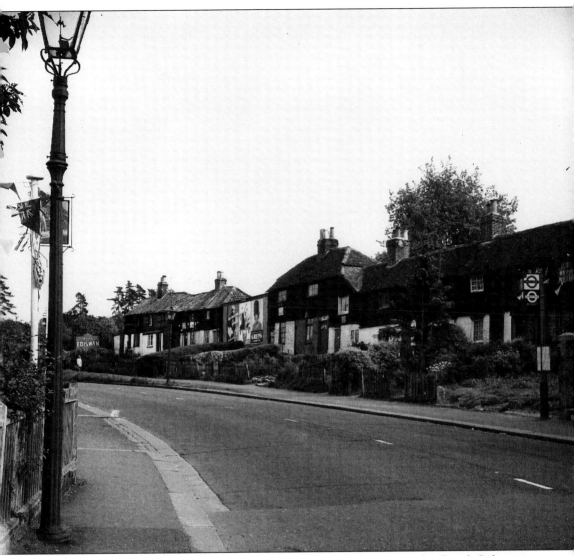

The Black Cottages uphill from Bushey Police Station and opposite the Royal Oak were supposed to have been erected for the men building the London to Birmingham Railway through Bushey and Watford in the 1830s. They were certainly rudimentary with few amenities. The flags celebrated the Coronation in 1953 and the Cottages were demolished on public health grounds not long after.

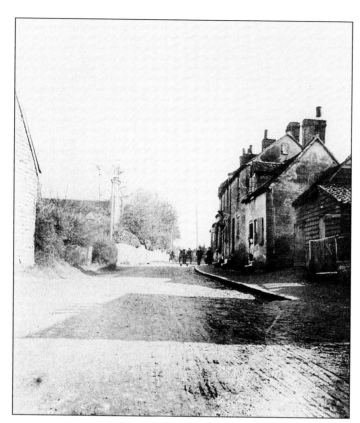

Ancient cottages opposite Ashfield Avenue and Catsey Lane were replaced by the present row of shops between 1900 and 1905, with some others added between the Wars. The barn on the left belonged to the old Queens Arms.

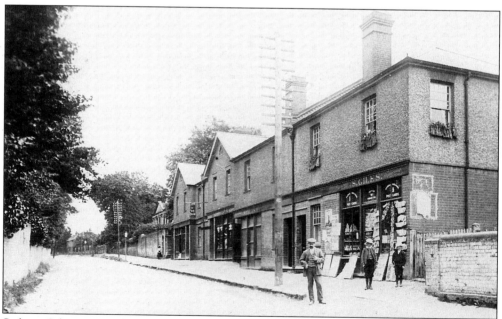

Sydney Giles was a tobacconist and newsagent in 1910, the only function to survive today. The other shops in the row were a hosiers, a grocers, a bakers, a watch and clock makers and a saddlers.

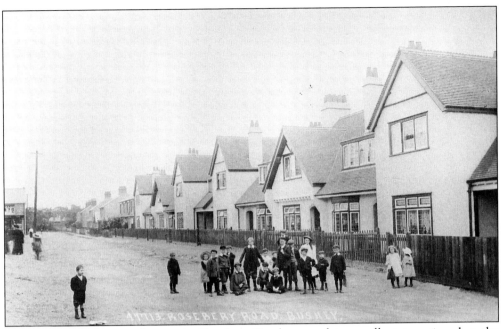

In about 1910 the new houses in Rosebery Road are architecturally interesting, but the photographer wants human interest and his camera proved a magnet for the local children.

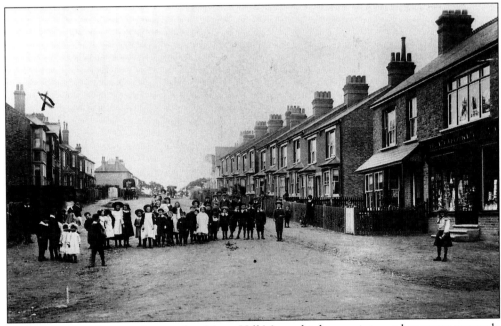

By the time the photographer reaches Merry Hill Mount his human interest has grown to nearly 60 children in a road with only about 30 houses in it. From 1905 to 1921, Henry Climance's general store served a community of about 120 households and still had to compete with the shops in School Lane.

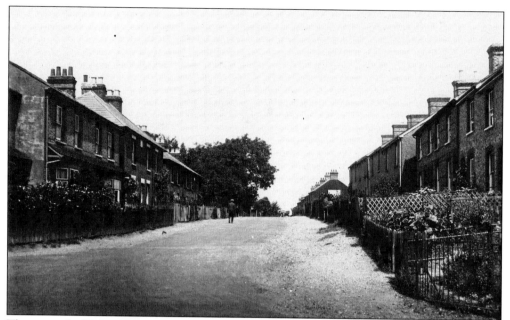

The top end of School Lane on a tranquil day in the 1920s.

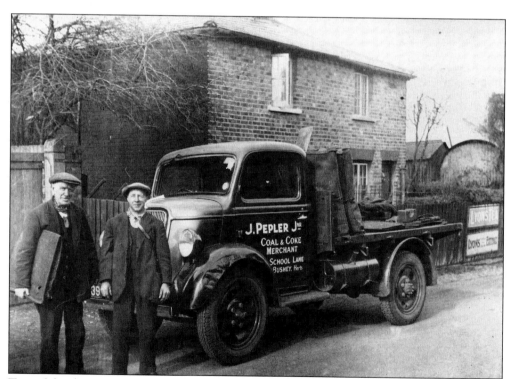

Two of the three generations of Peplers to carry on a coal merchant's business in School Lane sometime in the 1930s. The business survived into the 1960s.

Looking toward Whomsoever Lane from the top end of Merry Hill Road in the 1950s, before the complex of roads with birds' names, (often known as Birdland), was built on the old Hillmead estate.

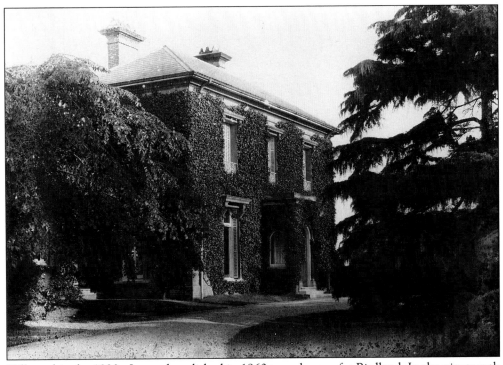

Hillmead in the 1920s. It was demolished in 1960 to make way for Birdland. In the nineteenth century it was called Sennoweville when it was the home of the Morse-Boycotts. Matilda Morse-Boycott presented a new font to Bushey Parish Church in 1874, in memory of her husband John.

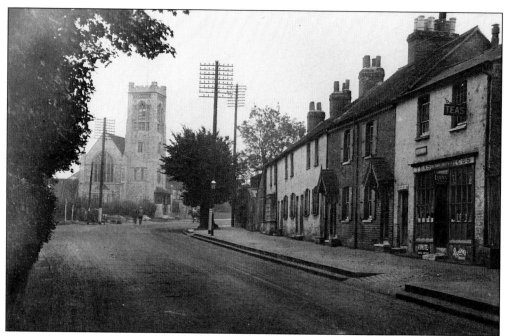

In the 1920s, the Quaint Sweet Box on the right sold teas and ices while fighting a losing battle against rising damp. Most of the cottages were eventually condemned and demolished, to be replaced by the Bushey and District Synagogue in 1984.

Sparrows Herne Hall, originally Laurel Lodge, was built in the late eighteenth century, probably for the Isherwood family. From 1827 they let it out until 1908, when it was bought by James Smith and then the Nimmo family from 1922 to 1948, when it was sold to Hertfordshire County Council.

Eight

Bushey Heath

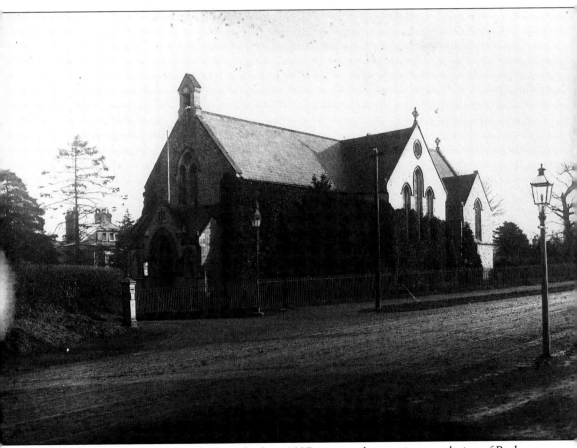

The first St Peter's was a chapel of ease built in 1837 to serve the growing population of Bushey Heath, which followed its enclosure in 1809. St Peter's, Bushey Heath, became a parish in its own right in 1889 and a more elaborate chancel was added in 1891. The unusual pillar box is a Penfold type, manufactured between 1866 and 1879.

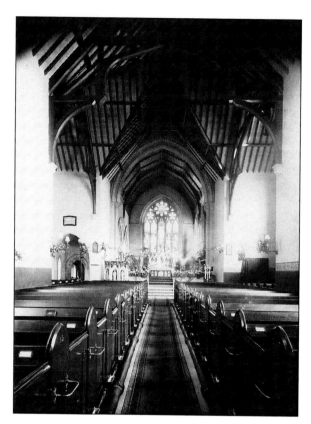

Despite its rather plain exterior the old St Peter's had a splendid timber roof. The pews were all numbered – and could be reserved – each having a small door.

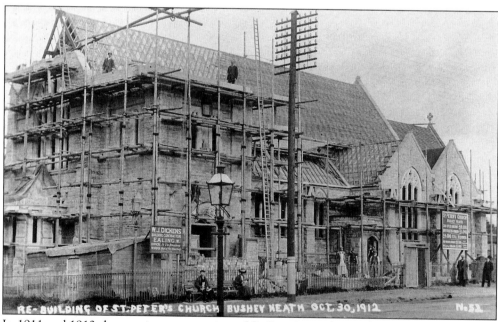

In 1911 and 1912 the growing congregation of St Peter's parish raised £10,200 to build a new church designed by George Fellows-Prynne. The 1891 chancel was incorporated into the new building.

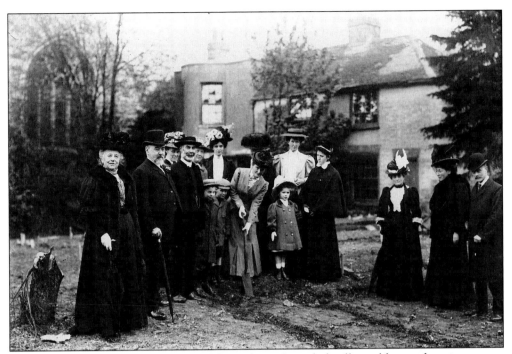

The Reverend Thomas Sadgrove stands by, as his wife symbolically wields a spade to inaugurate the building of St Peter's vicarage next to the old church in 1907. The vicarage was pulled down in 1970 to make way for St Peter's Close.

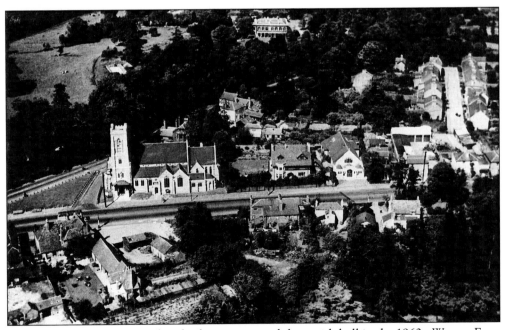

An aerial view of St Peter's church, the vicarage and the parish hall in the 1960s. Warren Farm is in the left foreground and Sparrows Herne Hall is in the centre distance.

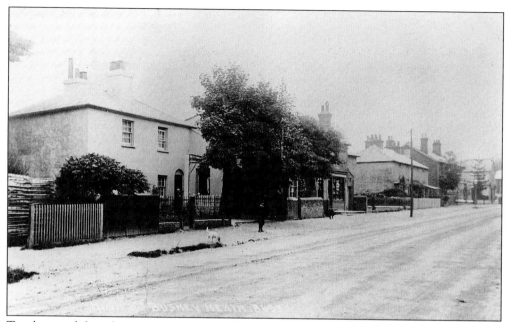

Two boys and their dogs are the only sign of life on a Sunday in Bushey Heath in 1905. Brown's timber yard (later Taverners), on the left, has long been replaced by a garage, but the houses and the shops in the centre survive.

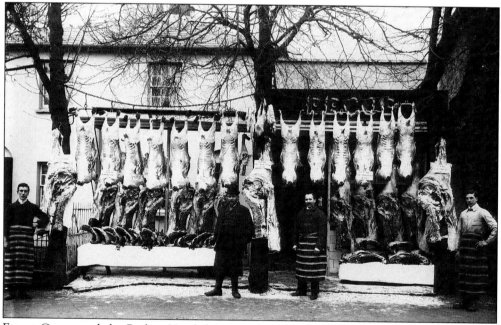

Ernest Coe owned the Bushey Heath butchers from 1904 to 1914. All the meat came from animals slaughtered on the premises. The carcasses are labelled with the names of local farmers and landowners, such as Blackwell, Baxendell, Cuthbertson of Bushey House and Comyns of The Warren.

114

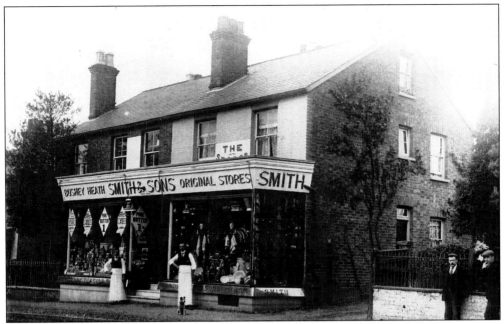

Smith's Stores was founded in about 1860 by William Smith, who dealt mainly in ironmongery. His son, Arthur Benjamin Smith, in the apron on the right, had expanded the business to include groceries by 1903, but the next generation cut back to ironmongery again after 1920. Smith's Stores survived until the 1980s.

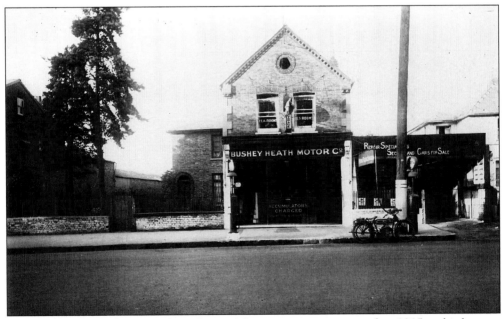

The first garage on this site, where Crown Motors now is, was opened in 1915 and it became Bushey Heath Motor Co. in 1925. The Stanley House Tea Refreshment Lounge upstairs was a short-lived venture.

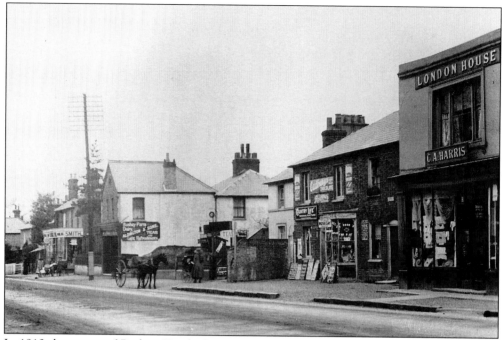

In 1912 the centre of Bushey Heath shopping on the north side, was between Smith's Stores and Harris' Drapers, with Aldington's Dairy to provide 'Teas and Light Refreshments'. Crown Motors now dominate the centre site of this scene.

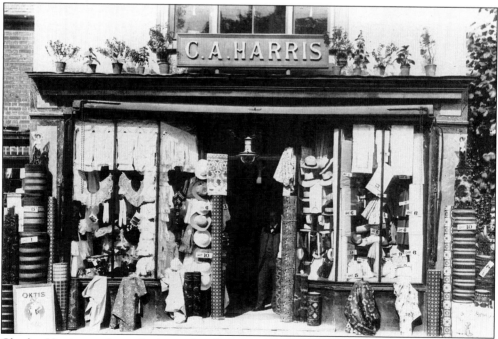

Charles Harris stands modestly in the doorway of his emporium which offered the highest quality lace collars and an infinite variety of Panama hats throughout the Edwardian period.

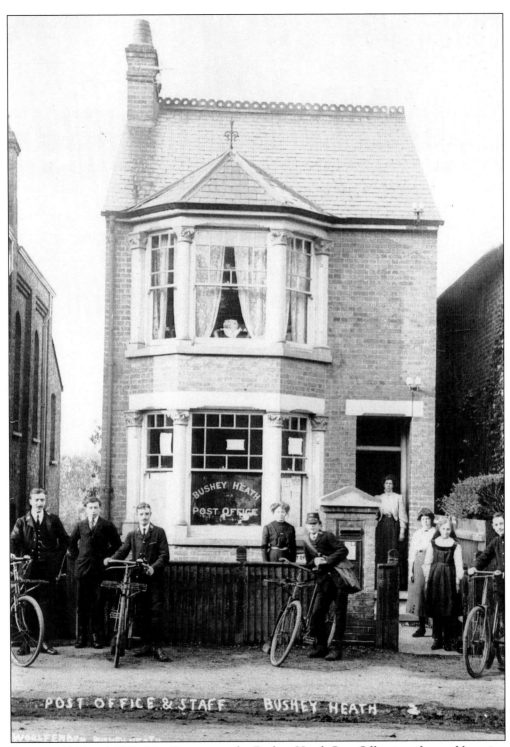

Between 1912 and 1930, Mrs Gurner ran the Bushey Heath Post Office in a former Victorian villa close to where California Lane joins the High Road, next to the old Methodist church. The nine staff in 1912, just after it opened, include two very young trainees and a telegraph boy.

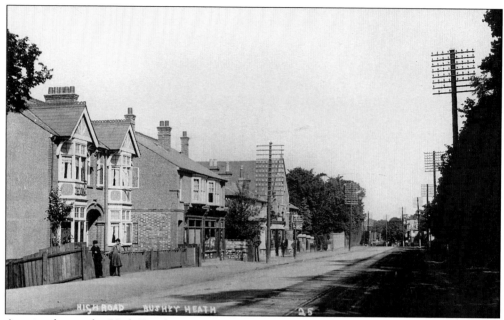

A quiet day in the High Road in 1912. One of the semi-detached villas has become a bank as Bushey Heath starts to develop. Rather ironically it is only these villas which survived the second sweeping development of Bushey Heath in the 1960s. Scaffolding shows the site of St Peter's in the distance.

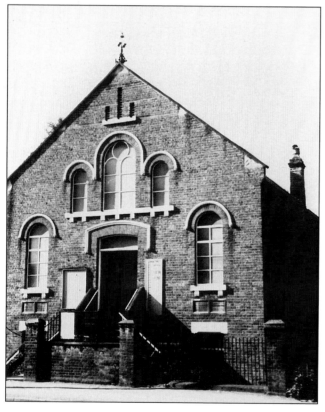

The Primitive Methodists first built an iron chapel in The Rutts in 1883 but soon outgrew it such that, by 1891, they had built an imposing chapel in the High Road near California Lane. Methodists of various persuasions united in 1932, which helped maintain their numbers, but by 1967 their chapel needed expensive renovation and they were glad to accept a developer's offer of a new church further along the High Road. The new St Andrew's Methodist Church opened on 14 September 1968.

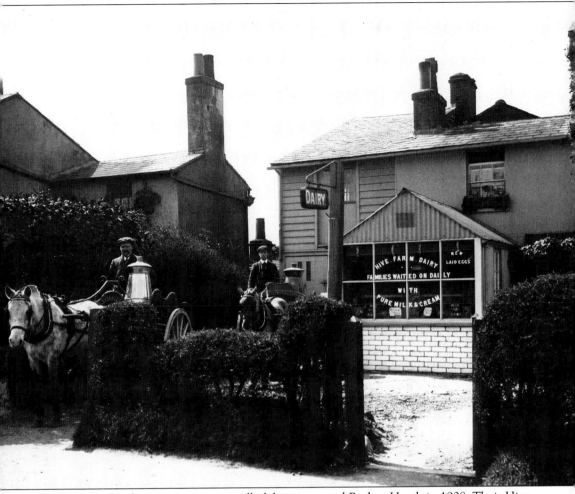

The Whatley brothers setting out on milk deliveries round Bushey Heath in 1908. Their Hive Farm Dairy next to the Foresters Arms was replaced by the first Alpine Garage in around 1930.

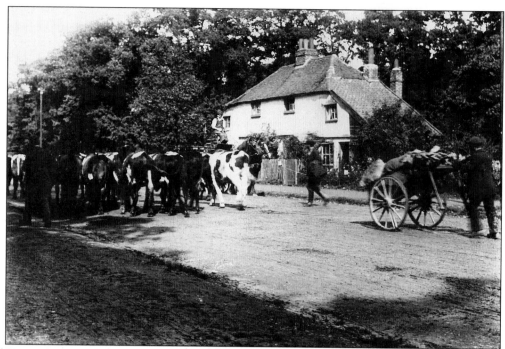

Heavy traffic in about 1910 past Hughenden Cottages in the High Road just by The Rutts. The cottages have remarkable catslide side roofs.

Skippers Cottages in Elstree Road next to the garage were similar to Hughenden Cottages in the High Road, although the catslides were shorter. Skippers Cottages were demolished in 1952.

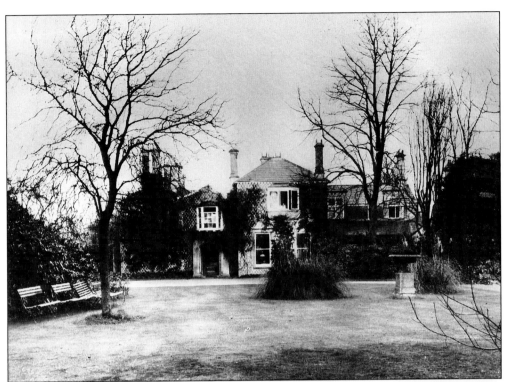

The Cottage, the last house in Hertfordshire on the High Road, in about 1910. In the nineteenth century, it was the home of Simpson Noakes who was reputed to have been the model for the popular representation of John Bull. This century, the Perrin family ran the Bushey Heath pottery there and, more recently J. Langham Thompson set up pioneering electronics laboratories in The Cottage and in its grounds. Hartsbourne Park flats now occupy the site.

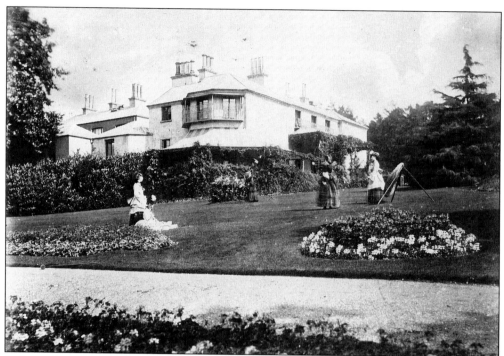

Ladies taking gentle exercise in acceptable diversions, such as archery and croquet, at Hartsbourne Manor in 1870. The genteel scene contrasts with the manor's earlier reputation which was notorious enough for it to be marked on maps as Thieves' Hole in the eighteenth century. In the Edwardian period, the celebrated American actress, Maxine Elliott acquired it for expected liaisons with the King, but he died before he could visit it. It is now a Country Club and Golf Club.

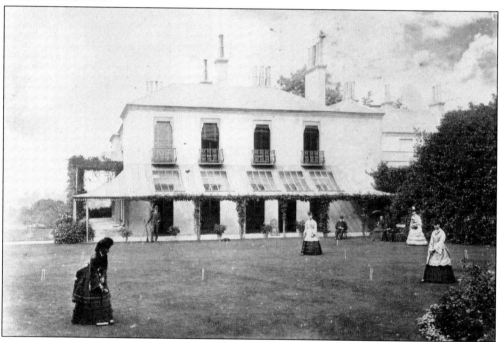

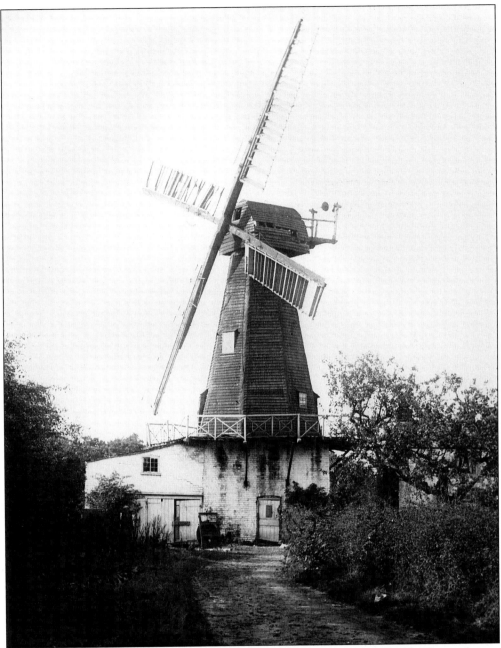

The Bushey Heath windmill in its final stages of dilapidation in about 1905. The track to it led from Windmill Lane, but it stood at the back of the present car park of the Black Boy in Windmill Street. It was a smock mill and ground flour, but in its later days the machinery was powered by steam and the sails were disconnected. How it finally disappeared is somewhat of a mystery and stories abound of disastrous fires or hurricanes or both!

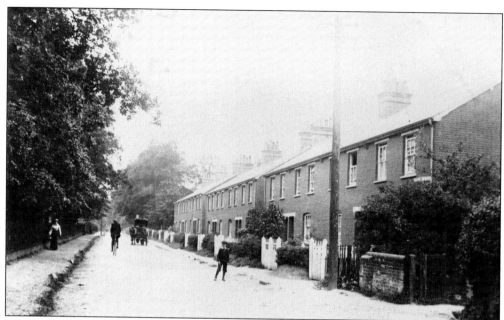

Windmill Lane in about 1908.

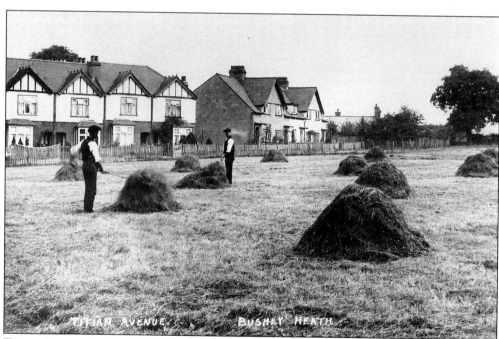

Titian Avenue in the 1920s. Percy Payne and a fellow worker from Caldecote Farm are haymaking in the meadow opposite the first houses.

Holly Grove House in Little Bushey backed onto the Kings Head in Little Bushey Lane. It was an early eighteenth-century house, carefully restored in about 1910. It was unusual in Bushey in that it was shingled. During the nineteenth century it had been a boarding school, but it later returned to private ownership. It was demolished in the 1960s.

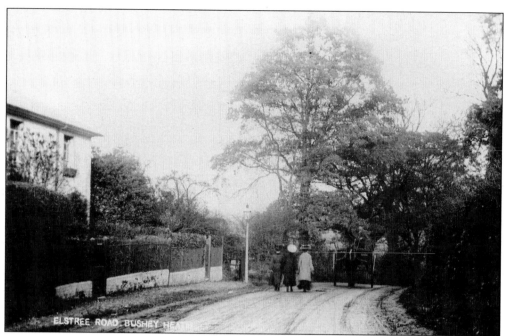

Three young misses are admired by the carter as they walk nonchalantly down Elstree Road in about 1910. This is the bend just before Elstree Road Garage.

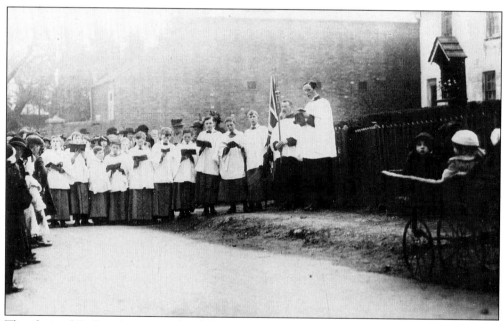

The choir of St Peter's sings at the dedication of a roadside memorial at the Reveley Lodge Cottages in Elstree Road. This event is probably during the Great War, when a number of such memorials were erected to commemorate grievous losses. The details of this memorial are at present unknown.